# A Spiritual Journey

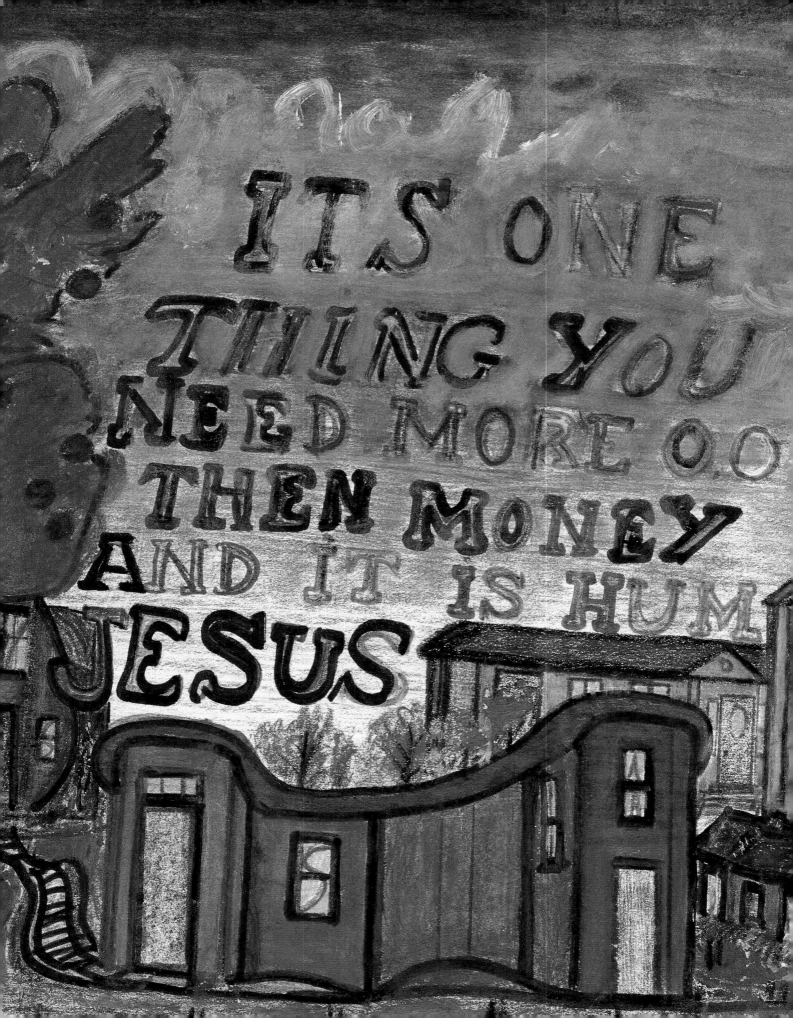

# A Spiritual Journey

## THE ART OF
## Eddie Lee Kendrick

Alice Rae Yelen

An exhibition organized by the New Orleans Museum of Art
with the cooperation of the Arkansas Arts Center

New Orleans Museum of Art
Distributed by University Press of Mississippi

This book is published in conjunction with *A Spiritual Journey: The Art of Eddie Lee Kendrick*, an exhibition organized by the New Orleans Museum of Art with the cooperation and support of the Arkansas Arts Center, Little Rock.

The exhibition, its national tour, and catalogue are sponsored by International Paper Foundation. Additional generous support for the exhibition and catalogue was provided by Dillard's; First Commercial Bank; Friday, Eldredge & Clark; Kristin Chase; and Dr. Alonzo D. Williams Sr.

*Exhibition Itinerary*

The Arkansas Arts Center      September 11–November 8, 1998
New Orleans Museum of Art      January 30–April 11, 1999

Library of Congress Catalog Card Number: 98-67000
ISBN 1-57806-111-3

Cover: *This Plane Is Heaven Bound* (cat. no. 23)
Back cover: Detail from *Holy Train* (cat. no. 24)
Frontispiece: Detail from *It's One Thing You Need More than Money* (cat. no. 33)
Page 3: Detail from *Fantastical Red Buildings with Angel Above* (cat. no. 50)
Page 6: *A Bed in the Sun* (cat. no. 41)
Page 13: Eddie Kendrick at Gibbs School, 1991. Photo: Steve Keesee, *Arkansas Democrat Gazette*
Page 15: Detail from *Come Try Jesus* (cat. no. 30)
Page 16: Eddie Kendrick, Higgins, Arkansas, 1988. Photo: Susan Turner Purvis

Dimensions are given with height preceding width.

Edited by Suzanne Kotz
Editorial assistance by Pamela Zytnicki
Designed by John Hubbard
Produced by Marquand Books, Inc., Seattle
Printed and bound by CS Graphics Pte. Ltd., Singapore

Distributed by
University Press of Mississippi
3825 Ridgewood Road
Jackson, Mississippi 39211-6492
1-800-737-7788

# CONTENTS

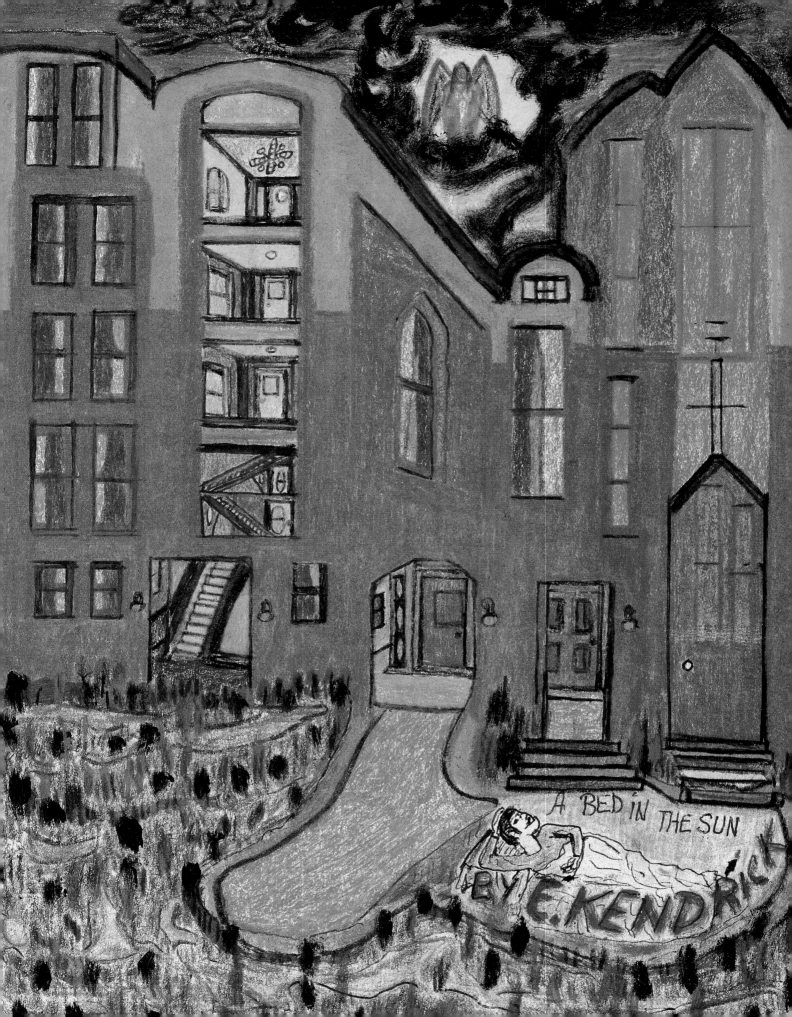

A BED IN THE SUN
BY E. KENDRICK

# FOREWORD

This exhibition of the work of Arkansas artist Eddie Lee Kendrick has developed according to the true sense of "community." Like most self-taught artists, Kendrick worked quietly on his own, without active involvement in the larger artistic mainstream of galleries and museums. He did, however, work within several communities that supported and nurtured him, and the works in the exhibition come primarily from lenders who had direct contact with him. Kendrick grew up within a large, encouraging family that never questioned his desire to paint. He belonged to a church whose fellowship fostered his intense spirituality and sense of connection to God. And he enjoyed periods of involvement with two school communities, each of which would play a pivotal role in bringing Kendrick's paintings to a wider audience. The artworks in this exhibition represent aspects of all these communities, either in subject or by ownership.

It is fitting that this exhibition, organized by the New Orleans Museum of Art, has been accomplished with the support and cooperation of the Arkansas Arts Center in Little Rock, Kendrick's hometown. The project is a manifestation of the long-time commitment of both institu-

tions to the field of contemporary American self-taught art. Sometimes called "folk" or "outsider" art, these works are produced by artists who have received little or no art training and, often, very little formal education. Only recently have the unique vision and aesthetics of the self-taught found an audience within the cultural mainstream, and both the New Orleans Museum of Art and the Arkansas Arts Center have been at the forefront in recognizing and promoting their art. The New Orleans Museum of Art has researched, collected (by gift and purchase), and exhibited the works of self-taught artists for more than thirty years. The Arkansas Arts Center also has long acknowledged the substantial contributions of self-taught artists by supporting an ambitious exhibition and collection program, international in scope, over the last twenty-five years. Both institutions have taken an interest in local artists at work in their respective communities: the Arkansas Arts Center was one of the first organizations to add a Kendrick painting to its collection, and the New Orleans Museum of Art held the first exhibitions featuring artwork by Louisiana natives Clementine Hunter, Sister Gertrude Morgan, and David Butler. We share the view that such artists are a valid and important part of the contemporary art world.

The name of Eddie Lee Kendrick first came to the attention of the New Orleans Museum of Art in 1992, while Alice Rae Yelen and her husband, Dr. Kurt A. Gitter, were intensely searching for artwork to represent each southern state in the groundbreaking exhibition *Passionate Visions of the American South: Self-Taught Artists from 1940 to the Present*. It was through contact with Susan Turner Purvis, a teacher in the Little Rock public school system, that Kendrick's paintings were seen by the exhibition's curators. Frail from his battle with cancer, the artist died just ten days after learning from Kurt Gitter that his work would be included in the show. It was with great pride that his family later visited the exhibition in New Orleans and witnessed the recognition that their father, brother, and uncle now garnered.

We are honored to present this first one-man exhibition of the works of Eddie Kendrick, a project that would not have come about without the foresight, tenacity, and dedication of Alice Rae Yelen. This exhibition is a continuation of her commitment to the work of contemporary self-taught American artists. She has been a leader in demonstrating the truly indigenous American nature of this work as well as placing it within the continuum of twentieth-century American art.

Finally, we wish to thank our sponsors for making this show possible and for allowing us to share the artist's splendid imagery in print with a broader audience. The exhibition, catalogue, and tour are generously funded by International Paper Foundation. Kendrick worked for International Paper for a time in the mid-1940s. Additional generous support came from Dillard's; First Commercial Bank; Friday, Eldredge & Clark; Kristin Chase; and Dr. Alonzo D. Williams Sr. In another display of community, it is appropriate that these supporters are from Kendrick's home state of Arkansas.

E. John Bullard
*The Montine McDaniel Freeman Director*
New Orleans Museum of Art

Townsend Wolfe
*Director*
The Arkansas Arts Center, Little Rock

# PREFACE AND ACKNOWLEDGMENTS

The rich, spiritually imbued works of Eddie Lee Kendrick might never have come to light but for a chance encounter. While employed as a custodian at Parham Elementary School in Little Rock, Kendrick covered the walls of his supply closet from floor to ceiling with his pictures, painted on ordinary cardboard. One day in early 1977 Ruth Kaplan, an art program administrator, happened to open the door to Kendrick's closet. It was, she recalls, "Like walking into another world." Kaplan immediately sought out the artist, requesting that he demonstrate his painting where students could watch and supplying him with art materials. After Parham Elementary was razed in 1979, however, Kendrick was reabsorbed into the ordinary rhythms of his life: going to work, participating in his church, and creating his artwork. A decade would pass before he again gained the notice of an outside supporter. Susan Turner Purvis, an elementary school art teacher and a protégé of Ruth Kaplan's, had met Kendrick at Parham. In 1988 she asked him to exhibit three recent paintings at her Little Rock school, Gibbs Magnet School of International Studies and Foreign Languages, as part of its celebration of Black History Month, and three years later

she invited him to be artist-in-residence at the school during February, again in recognition of Black History Month.

During his tenure at Gibbs during 1991, Kendrick spent two or three days a week at the school. He worked in the art space in the hall (there was no art classroom), where children could come and observe as they went to and from their classes. Supplies were purchased for his use with money the children had been awarded in the Barrett Hamilton Young Arkansas Artists Competition and Exhibition. With the blessing of Gibbs principal Donna Davis, Kendrick extended his stay through May. Neat and methodical, Kendrick wore a denim apron borrowed from Purvis while he painted. Each night he took his paintings, brushes, and paint home so he could continue to work into the evening. His finished paintings were displayed on a bulletin board in the hallway, much as he depicted in the autobiographical *God Bless* (cat. no. 61), in which Kendrick paints at his desk, surrounded by students and staff, with representative works pinned to the wall behind him. As word got around that he would give students a painting if asked, children began to request his works, which he freely gave away.

Kendrick was clearly gratified by the contact he had with the students and staff at Gibbs. Like many self-taught artists, he lived in a supportive culture that acknowledged his artistic hobby but did not necessarily place the same value on art that others might. Perhaps because his peers did not, Kendrick did not elevate his art: he made no particular effort to conserve his work, and neither did most family members or friends. Nonetheless his family understood its importance to him, saying that it was always just a part of him.

Kendrick always held a job and never looked to his art as a means of support. This allowed him to stay pure and authentic in his artistic renderings, developing them as his instincts and beliefs guided him. In this he resembles many self-taught artists, who typically are driven to create art by an inner voice that has little to do with conventional art making or its politics. Kendrick's work, although a reflection of his religiosity, was not overtly evangelical in the sense of other self-taught artists who also considered themselves preachers or instruments of the Lord. Kendrick was inspired by religion, however, and throughout his life he actively participated in an organized church, most notably the Church of God in Christ.

Kendrick generously shared his pictures, as he had with the children at Gibbs and Parham, with anyone who expressed interest in them. "The kids like to see [the paintings]," he said, "and I like to give them to the kids. . . . I've given all my goods ones away" (*Arkansas Gazette,* March 13, 1977). The ease with which he gave away his paintings complicated their retrieval for this exhibition. Fewer than two hundred works came to light during the course of my research, although we contacted the hundreds of students and teachers who had known Kendrick at Gibbs as well as his colleagues and the managerial staff at Brown Packing Company, Inc., where Kendrick worked for close to three decades. Articles about the project appeared in the Little Rock newspapers but yielded few leads. In the end, the works in the exhibition have come primarily from family, close friends, students, teachers, coworkers, and the few art enthusiasts Kendrick had met along the way. I thank each lender for graciously agreeing to loan the artwork in his or her possession. The sixty-five works in the exhibition fall into three periods: 1977–78, 1985, and 1991–92. The majority come from these last two years of his life. It is my hope that, with this exhibition, more works will come to light.

Kendrick did not apply formal titles to his paintings, although his inscriptions are a rich source. In a dilemma familiar to anyone dealing with the work of the self-taught, I struggled with how to respect the artist's words and spelling while ensuring the readability of the catalogue captions. In the end, because the paintings are reproduced in full and in color, I have used conventional spellings to transcribe titles taken from inscriptions, and I urge the viewer to experience Kendrick's original text by viewing the paintings.

Dating the works was another area of concern. Kendrick applied dates to few works, but because he was

known to give paintings away soon after they were finished, I established a hierarchy of dates according to what lenders could tell me about when they had acquired them. I expanded this framework according to my knowledge of the various materials supplied to him at different times and using an inventory of the materials found in his home after his death. I then relied on technique and subject to give me additional clues.

I owe a special debt of gratitude to John Bullard, director of the New Orleans Museum of Art, for his willingness and trust in approving this exhibition. His continued leadership and support on behalf of contemporary self-taught artists is a source of inspiration. I also thank Townsend Wolfe, director of the Arkansas Arts Center, for becoming our partner in this exhibition. He has been unstinting in offering advice and information, which has greatly benefited the outcome of the exhibition and its catalogue.

At the New Orleans Museum of Art, I extend my gratitude to the many colleagues who performed their jobs with good humor and zeal: Jackie Sullivan, assistant director for administration, gave generously of her time to advise me on all fiscal matters; Gary Porter, project assistant, carefully entered and safeguarded Kendrick data, slides, interviews, and correspondence; Dore Levy, a committed volunteer intern, assisted in assembling the checklist by meticulously verifying dates, signatures, and text on each artwork; Will Drescher, museum photographer, provided the magnificent catalogue photography; Mike Strecker, development officer, effectively assisted in the grants process; Annie Williams, public relations director, enthusiastically spread the word about the project; and John Hankins, outreach coordinator, made connections to the local African American and church communities. Conversations with Steven Maklansky, curator of photography, and Lee Morais, assistant director for education, were invaluable to me in organizing my approach to the exhibition. Others who gave much appreciated help include John Albano, Joyce Armstrong, Mike Guidry, Lynn Dabney Harrington, Thom Herrington, Jennifer Ickes, Denise Klingman, Brigett McDowell, Wanda O'Shello, Pat Pecoraro, Dan Piersol, Whitney Stone, and Paul Tarver.

My visits to the Arkansas Arts Center were easy and fruitful, and I extend my sincere thanks to the center's staff, particularly Michael Preble, head of education; Thom Hall, registrar; Brian Young, curator; Charlotte Brown, director of development; Ellen Becker, special programs director; Becki Moore, marketing and public relations director; Lynnette Watts, assistant to the registrar; Jody Tips, education assistant; and Carolyn Crockett, secretary to the director. The center played a vital role in packing and shipping artwork, soliciting loans, gathering essential information, and fund-raising.

In addition, I had the good fortune to work with a number of individuals whose assistance and advice was of immeasurable value: Dr. Marcella Brenner, Sue Campbell, Maxine Payne Caufield, Dr. Tom Greer, Tommy Jameson, Ruth Kaplan, Susie Robinson, Dr. Jan Rosenberg, Rev. R. N. Sanders, Dr. Madison Slusher, Dr. Martha Vail, and Steve Weil. The students and staff at Gibbs School are an essential part of Eddie Kendrick's story, and I thank all those who took the time to be interviewed.

I wish to extend my sincere gratitude to Susan Turner Purvis for her tireless efforts on behalf of the art of Eddie Kendrick. It was Susan who first brought his paintings to my attention when, with Kurt Gitter, I was selecting works for inclusion in *Passionate Visions of the American South,* an exhibition of contemporary southern self-taught artists. Susan provided critical links to the students at Gibbs School, to the Kendrick family, and most important, to the lifestyle and landscape of Eddie's Arkansas. Her recollections of Eddie and his working methods were critical to the development of my essay, and as a local liaison to the Little Rock community, she facilitated my visits to the Arkansas Arts Center, introduced me to many fruitful sources as I tested my theories, and followed up on myriad details. Without her always methodical research and knowledge of her community, and her deep and abiding respect for the artist, this project would have been far more difficult to achieve. I would also like to thank

her dear husband, Joe Purvis, for his active support of our efforts.

My husband, Kurt Gitter, had a critical role in establishing this exhibition. It was Kurt who visited Eddie as we organized *Passionate Visions,* and his heartfelt response to Eddie's powerful imagery and personal spirituality encouraged me to delve into the artist's life and work. I thank Kurt for his commitment and support throughout my long absorption in this material. And to our daughter, Manya Jean, I say thank you for your sweet tolerance of the many evenings I spent at the computer. I hope in your adult memory it will inspire you to care passionately about your own work. To my sister, Susan, and my brother, Richard, thank you for your continuous faith in my ideas.

I owe my deepest appreciation to Eddie Kendrick's gracious and caring family. They gave me a path to Eddie which I never would have found on my own. Darlene Deadmon, Eddie's sister and the family historian, patiently responded to my many questions; brother Herman shared his insights on Eddie and gospel singing; and brother John, also an artist, gave precious details about Eddie's tenure at Parham School. Kimberly Kendrick, Eddie's daughter, quietly supported the show and loan of works, and DeVonie Cunning, his stepson, enthusiastically shared recollections about his father and his art. Eddie's sister, Lucy Parker, and his uncle, Elton Kendrick, are now deceased. Each of them helped me: Lucy, in sharing family history, and Elton, in literally and figuratively opening the doors of Eddie's church. Cousin Berdie Conway and niece Alma Smith also provided helpful documentation. It has been a privilege to work with this dignified and proud family.

One of my goals in assembling this exhibition was to promote the serious study of the work of contemporary American self-taught artists, a task most readily accomplished through the publication of monographs such as this catalogue. Several individuals were critical in its production. Tanya Ferretto was consistently helpful during the writing phase, and I am grateful for her cheerful application of her computer skills. I thank Ed Marquand for freely sharing his advice at the developmental stages of the project and John Hubbard for creating the book's beautiful design. To Suzanne Kotz, a gifted, patient, and sensitive editor, I express my warm appreciation.

The success of this project depended on the trust and support of two key funders. The early commitment and kindness of William Dillard Sr. of Dillard's gave us a critical impetus in bringing the exhibition together, and generous funding provided by International Paper Foundation through the offices of the always supportive Ronnie Howell was an essential element in our success. To each of them, I extend my sincere gratitude.

Alice Rae Yelen
*Assistant to the Director and Associate Curator of*
*Contemporary American Self-Taught Art*
New Orleans Museum of Art

# HANDS AND HEART:
# A REMEMBRANCE

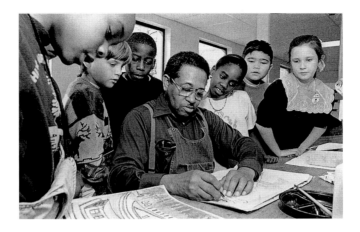

Seven years after he was in our midst, a vivid image of
Eddie Kendrick remains with me. He sits alone at my
table working diligently on his art in the bright, sunlit hall-
way of Gibbs School. It is perfectly quiet after the noise of
midday activity. The children have all returned to their
classrooms and no longer surround the artist. It is a peace-
ful image.

That February afternoon in 1991, I interrupted his
solitude to visit with him and to interview him. Eddie was
a reticent man, and he did not offer elaborate answers to
my questions. His responses were as staccato as the blades
of grass that he drew. During our visit, he told me that
"Precious Lord" was a favorite hymn. The first words of
the song, "Precious Lord, take my hand," evoke another
lasting image of Eddie—his hands.

Like the folk art master Elijah Pierce, Eddie had large
hands. But unlike Elijah's graceful hands and slender fin-
gers, Eddie's hands were strong with thick fingers. They
were hands that tilled the soil of Arkansas and cut 200-
pound cross ties from oak logs. They were the skilled
hands of a butcher who felled hogs with a single blow.
They were also gentle hands that healed. Like self-taught

artists Bessie Harvey and Lonnie Holley, Eddie was a healer in his community. About Eddie's ministering, his niece Alma Smith says, "I believe it was a gift from God." She goes on to share a story that illustrates Eddie's ability. The two worked together as butchers at Brown Packing Company. One day Alma developed a bad headache and told a skeptical coworker that she was going to have Eddie use his blessed oils. He put the oil on his fingers and rubbed her temples and "drew the headache out." Alma smiles and says, "All I know is that it worked."

Eddie's daughter Kimberly and stepson DeVonie Cunning also remember being anointed with the blessed oils as Eddie prayed for them when they were ill. Kimberly recalls that her dad cut up dried cow chips and boiled them to make a healing tea when she had a cold. He also gave the children rubdowns when they were sick, a skill he had learned from his mother.

They were gentle hands that comforted. MiEsha Coates, a fifth grader at Gibbs, found in Eddie a much-needed father figure. She often spent time with him as he worked in the art space outside the cafeteria. Eddie complimented her beautiful smile and sang "This Little Light of Mine" to her one day when she felt ill. When MiEsha became apprehensive about performing in the annual school musical, she talked to Eddie about her fears. He reassured her by making a cross between her eyebrows with the blessed oils he carried with him.

Eddie's hands were also sensitive, which allowed the artist within him to speak through his paintings and drawings. Often he included a guardian angel who, he explained to MiEsha, always watches over you, even on bad days. Sometimes with words, most often with colorful images of earthly and heavenly homes, he spoke of his faith and the meditations of his heart.

Alma Smith describes her "favorite uncle" as good-hearted: "Everything he did, he did from his heart." Eddie's siblings credit their mother with teaching all the Kendrick children to share. Darlene Deadmon describes her beloved older brother as "a very giving person" who would buy food for those in need even when he did not

have money to spare. "He would have given the shirt off his back," she says.

Eddie was generous with his time. The months he spent at our school as an artist-in-action were all volunteer hours. He seemed to especially enjoy quiet visits with members of our Gibbs family, particularly the children. Clara Kitchen, former school custodian, comments, "The children were drawn to him without [his] saying anything." On the way to recess or specialty classes, they stopped and peered over his shoulder. Erin Blome remembers stopping with a group of other second graders and watching Eddie work on a painting, which he later gave to her. Using a dry brush, he began to apply paint onto a preliminary drawing. Then, without saying a word, he took her hand and guided her fingers to smear paint onto the clouds.

For many of our school family, Eddie was a mentor. Former student Ayonna Shenice Turner often visited with him after school. Ayonna says that she learned by watching Eddie work: "He could be drawing grass with green and then put brown in it and go back to green. I do that now." When MiEsha told Eddie that she could not draw but that she could write, he explained the creative process simply: "When you write, let your fingers do the work."

For Keith Price, former Gibbs custodian, Eddie became a father figure. When Keith speaks about the artist, he becomes reverent: "He always encouraged you. He could find something good about everybody. He always said that behind every dark cloud there is a silver lining."

The first stanza of "Precious Lord" ends with "through the storm, through the night, lead me on to the light." Eddie Kendrick found the light. It glowed from within him just as it glowed from within the buildings he loved to paint. That afternoon as Eddie sat working in the hallway, there was an aura about him. It was the light of God's grace, and its radiance touched all those around him.

Susan Turner Purvis
Little Rock, Arkansas

# LENDERS TO THE EXHIBITION

| | |
|---|---|
| Melverue Abraham | Crystal Jones |
| Lashanda Allison | The Kendrick Family |
| Robert Allison | Nancy and Russ McDonough |
| Tiffany Allison | New Orleans Museum of Art |
| The Arkansas Arts Center | Benjamin H. T. Purvis |
| Louise Bloom | Elizabeth G. Purvis |
| E. John Bullard | Joseph H. and Susan Turner Purvis |
| Patrick Cowan | Brandon L. Reeves |
| Tiffany C. Cravens | Laura Sanders |
| DeVonie L. Cunning | San Diego Museum of Art |
| Connie Fails | Will Staley |
| Jonathan Fields | McDowell and Mary Nell Turner |
| Tim Goetz | Evita A. Washington |
| Suzanne Clark Golden | Corrie White |
| Dorothy and David Harman | Susan C. Yelen |
| Bill Hawes | Private Collections |

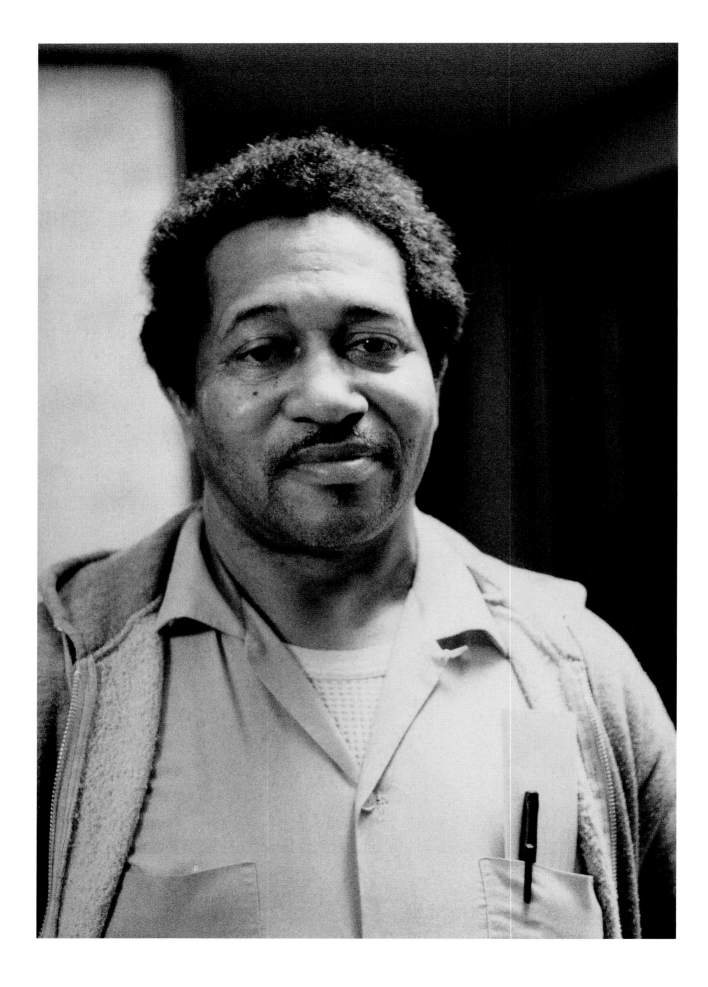

# Eddie Lee Kendrick

## ALICE RAE YELEN

Eddie Lee Kendrick was born on September 20, 1928, to life on a farm near Stephens, Arkansas, approximately 120 miles southwest of Little Rock. The son of John Henry and Rutha Mae "Ruby" Kendrick, he was the oldest of fifteen children, thirteen of whom lived to see adulthood. In his youngest years, his family worked as sharecroppers and, later, as independent farmers, growing cotton, sorghum, peas, peanuts, corn, watermelon, and cantaloupe and raising hogs, chickens, and cows. Eddie and all the children worked the farm with their parents and grandfather, and he attended the one-room Springhill School. As a young boy, Eddie helped in the annual slaughter of four or five hogs, which were then cured in his grandfather's smokehouse over hickory that grew on their land. In his teen years he worked with his father cutting wood for a company that made railroad ties, and in the mid-1940s he took a job at International Paper, a paper mill.

In 1944 or 1945, the family moved to Longley Settlement in Pulaski County, in the southwestern outskirts of Little Rock. All the children attended Longley School, a white frame, one-room school for African American children from grades one through seven. Eddie's formal

schooling, which had been interrupted over the years by the necessity of helping out on the family's land, ended there with the seventh grade.

As a young adult Kendrick worked for Hines Packing in Little Rock, and in his early thirties he moved to Brown Packing Company, where his father and five brothers also worked. He began on the kill floor, slaughtering hogs, and worked his way up to the meat cutting section of the plant. Kendrick remained at Brown for twenty-nine years, with intermittent breaks. He married twice and, through his second wife, was stepfather to three children: DeVonie, Shannon, and Latoya. He fathered one child, Kimberly Kendrick, through another relationship.

In the mid-1970s Kendrick briefly lived in Oklahoma City, working for Holiday Inn, but after his father suffered a stroke, he returned to Little Rock, and in late 1976, he went to work as a custodian at Parham Elementary, a public school. It was there that Kendrick's artwork was first seen by Ruth Kaplan, an arts and education administrator in the Little Rock school system. His earliest documented works come from this period, when Kendrick was nearly fifty years old, although family members recall that he had always drawn, and his uncle, Elton Kendrick, remembered encouraging him to draw.

Kaplan was astonished when she one day came upon the custodian's closet at Parham, its walls literally covered with Kendrick's paintings on corrugated cardboard.[1] Impressed by his work but concerned that the glue in the cardboard would cause the painting surface to deteriorate, Kaplan allotted funds from her art program to supply Kendrick with acrylic paints and paper. With the support of principal John Pagan, she hired Kendrick and his brother John, also a custodian at the school and an artist, to work for one hour a week, on different days, at a painting station where schoolchildren could observe and interact with them. Kendrick continued as an artist-in-residence until 1979, when the school was razed for construction of a freeway. He returned to the meat packing business at Brown, where he stayed until retirement in 1990.

The church played a central role in the culture in which Kendrick lived. As a child, his family attended the Bethel African Methodist Episcopal church near Stephens, and when the Kendrick family moved to Little Rock, Eddie joined a church there. He and his family sang in several gospel groups, including the Kendrick Brothers (also known as The Southernaires), Gospel Wonders, Hearts of Joy, and Twin Harmony Five. During the time he created the body of artwork that survives, from the late 1970s until his death in 1992, Kendrick participated as a congregant, choir soloist, and deacon in the Woods Temple Church of God in Christ, in Higgins, on the outskirts of Little Rock.

A Pentecostal sect, the Church of God in Christ was strong in Arkansas for decades before Kendrick's birth, and it was the fastest-growing church in the country during the period of Kendrick's involvement.[2] It was founded in 1907 by a dynamic black minister, Charles H. Mason, after his own church rejected Mason's demand that it embrace the charismatic experience of baptism by the Holy Spirit. Like other Pentecostals, members of the Church of God in Christ seek spirit baptism and its supernatural evidence—which (according to 1 Corinthians 12:4–11) might express itself as speaking in tongues or as the ability to prophesize or heal.[3] Individual possession and use of these gifts represent the ultimate service to the Lord. The authority of the church is held in scripture, the "Word."

Kendrick himself called his painting his "gift," even if it did not fit snugly as one of the gifts of the spirit defined in I Corinthians. Like many southern self-taught artists of his generation, he was comfortable speaking from the voice within. And as is true for many religiously inspired self-taught artists (they are often self-proclaimed preachers), the independence of his church allowed him to live within its guidelines while using his talents to express a personal interpretation of God and his relationship to him. Self-taught artists often say that the Lord directed them to paint,[4] and while Kendrick acknowledged his ability as the Lord's gift, he did not consider it a directive: "It was in me," he said, "it's one of my gifts."[5] Unlike the

preacher/artist (such as Howard Finster or Sister Gertrude Morgan), who consciously used his or her work as an evangelical tool, Kendrick did not seek an audience. Like a prayer, his paintings were private. Only a select group of family members and friends even knew of his artwork, and most never saw it. His extant paintings, in fact, date almost entirely from the two periods in which outsiders took a particular interest in his activities: 1977–78, when Ruth Kaplan first discovered his work, and 1991–92, when teacher Susan Turner Purvis, a protégé of Kaplan's who had known Kendrick at Parham, invited him to her school in Little Rock as an artist-in-residence during Black History Month.

Kendrick's paintings—his personal communications in praise of the Lord—were influenced most strongly, according to the artist, by scriptures, singing, music, praying, and dreams.[6] As an ardent gospel singer and church choir member, Kendrick was quite familiar with the gospel song repertoire, which included his favorite hymns "Jesus Keep Me Near the Cross," "Precious Lord," and "And God Will Take Care of You." "When you get some good music," he said, "you can draw about anything."[7] As a deacon in his church and as a highly spiritual man, Kendrick held scriptures and prayer close to his heart, and they took form in his work in both word and image. "Prayer is good in the morning," he inscribed on one painting (cat. no. 19), "to keep us right from wrong." His dreams were linked to the otherworldliness of his spirituality, and he followed their lead. Kendrick's sister, Darlene Deadmon, recalls that her brother would keep a pencil and paper near his bedside to sketch his dreams when he rose from sleep. He sometimes turned these sketches into paintings.

Like many self-taught artists, Kendrick repeatedly adapted his technique to accommodate the materials available to him. His sister Darlene remembers that he would begin to draw on the brown kraft paper grocery bags just as soon as his mother unpacked them, and Elton Kendrick recalled that Eddie would "paint on anything he could put a mark on if he couldn't get some paper."[8]

When Ruth Kaplan discovered his paintings, he was using typical school supplies—tempera and watercolor combined with crayon, pencil, and ink. With her program's financial assistance, Kaplan acquired acrylic paint, pen, pencil, glitter, and markers for Kendrick.[9] Later, in 1991, Susan Turner Purvis offered Kendrick his choice of supplies, and while he requested oil paint and paper, he now also experimented with the Prismacolor pencils Purvis gave him. He became particularly expert at a range of effects with the colored pencils, which allowed him to perfect the fine drawing and precise, hard-edge architectural lines of his early work. With the pencils Kendrick also achieved remarkable jewel tones, as dense and rich as a painted surface. He occasionally applied a very thin brush of oil paint over a penciled surface.

Kendrick used various media—selecting from acrylics, oils, pencil, ink, and glitter—and he varied his support materials. Although he always used paper, at various periods he concentrated on corrugated cardboard and, later, fabric and board. These choices in some part were directed by what was readily available to him, although he clearly enjoyed perfecting his use of particular media. He restricted his use of metallic media—whether paint, pencil, or glitter—to a specific context, using it only to signal Christ's aura or divine radiance. He often preferred a dry brush and a stippled effect, applying small dabs of paint to render grasses and flowers.

Kendrick tended to work in a three-part process, first drawing key features of a work's composition with ballpoint pen or pencil, then filling in with paint, and finally outlining in a bolder or thicker line, to clearly define the boundaries of buildings, figures, or objects he wished to highlight. Aesthetically strong, Kendrick's drawings are complex and detailed, and could stand on their own without the artist's skillful use of paint (see, for example, cat. nos. 64, 65). These carefully detailed drawings support even works that, when finished, appear painterly and loose, such as Christ with Pink Angels (cat. no. 9). In general, however, Kendrick's lines were deliberate and hard, and in some architectural renderings he relied on a

straightedge. Although he varied his materials over time, this working method remained consistent. In the early works, underdrawings are filled in with acrylic and outlined in markers or acrylic. In later works, underdrawings are in oil paint and/or colored pencil, then outlined in markers, colored pencil, or oil. His process is visible in a section of *Baptism in Front of Buildings with Christ Above* (fig. 1) in which Kendrick drew the legs and shoes of some figures but inadvertently neglected to either fill in or outline them, as he did for the surrounding figures.

Kendrick's concept of painting was closer to nineteenth- than twentieth-century aesthetics. A finished painting for him meant that the work's surface was completely and meticulously covered with paint; he had no intention of allowing interplay of negative space or integrating the unprimed background with the surface. Although he used painterly brushstrokes to create skies and in later works abstracted his representations of buildings, Kendrick generally adhered to his meticulous and careful style. He had a clear notion of when a painting was completed (he once asked a buyer to return the next day for a painting so he could add glitter).[10] On occasion he pursued traditional

framing notions by mounting works onto a larger posterboard or other support, sometimes inscribing text on the frame's border (see, for example, cat. nos. 12–14).

While he never worked in three dimensions, from the beginning, Kendrick's imagery reflected his interest in creating the appearance of depth. At first he used fairly simple, horizontal bands of figures, buildings, and landscapes which receded slightly back into the picture plane. In later works, shallow pathways and stairs deepened, directing the viewer's attention along several planes via angular stairways, curving roads, serpentine paths, and rounded, fantastical architecture.

Pathways in particular emerged as a critical device, which Kendrick used to arrest and focus the viewer's exploration of individual works, guiding the eye through space and subject. Kendrick achieved his paths in a range of pictorial guises ranging from actual dirt paths to winding roads, grass rows, and meandering waterways. Sometimes a path wrapping along the bottom edge of a painting works almost like a border but also as a device that determines the depth at which the viewer enters the picture plane. In later pictures, Kendrick pursued perspective with

Fig. 1   Detail from *Baptism in Front of Buildings with Christ Above* (cat. no. 3), showing Kendrick's three-part process: underdrawing, filling in, and bold outlining.

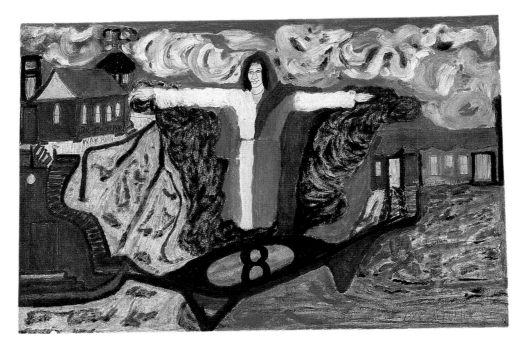

Fig. 2 *Christ on the Eight Ball,* c. 1991, collection of Hillary and Catherine Ahart.

more aggressively placed diagonal and curving paths that bisect pictures or give them added depth.

The path or unpaved road in Kendrick's paintings is a literal reflection of the artist's experiences in rural Arkansas, where children walked a lot and often on unmarked paths. But the concept of "the path" also has a firm basis in scripture, most notably in Psalm 23:3: "He restoreth my soul: he leadeth me in the paths of righteousness for his name's sake." Several of Kendrick's works confirm his intention that the path or "the way" functions not only as a compositional but metaphoric element. In *Gospel Group and Choir* (cat. no. 5), for example, a vertical pathway serves pictorially to separate the two groups of singers but also points the way upward to a small, graceful image of Christ stepping onto a horizontal stream of clouds. The path leads the eye to Christ, and the choir members also try to steer us to his realm by singing "Stop now, its praying time,"[11] the activity that gets one on the road to Jesus. Kendrick reinforced the symbolic importance of his pathways by inscribing cautionary warnings, as in *Turn and Go*

*the Right Way* (cat. no. 14) or in the wonderfully literal *Christ on the Eight Ball* (fig. 2), in which Christ points with one arm toward a church, the "righteous way," and with the other hand gestures toward the "wicked way."

Kendrick derived several potent images from the particular ambiance of the Church of God in Christ at which he worshiped in Higgins. A rectangular wood and concrete block building (fig. 3), it is typical of many small town southern churches, with an unadorned exterior and a plain interior (for Kendrick's only literal renderings of his church, see cat. no. 18; figs. 4, 5). It was the richness of Kendrick's experience of the church more than its physical features that inspired him, but he nonetheless transported certain of its attributes into his artwork, such as the exterior floodlights that frequently illuminate his painted buildings (cat. nos. 43, 47). Inside the church, a few small frosted glass windows simply but effectively define the sacred space within and separate it from secular life outside. This notion of separation is particularly evident in Kendrick's early pictures, in which he divided picture space

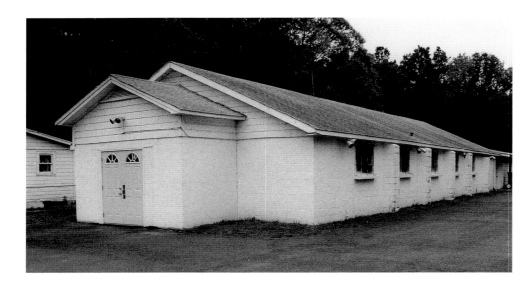

Fig. 3 Kendrick's church, Woods Temple Church of God in Christ, Higgins, Arkansas. Photo: Maxine Payne Caufield.

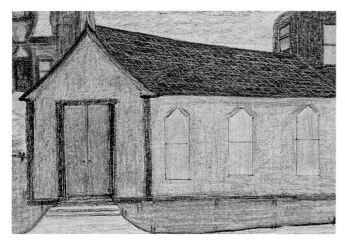

Fig. 4 Detail from *If Jesus Call You Now, Are You Ready?*, c. 1992, private collection. This building bears an interesting likeness to the exterior of Kendrick's church.

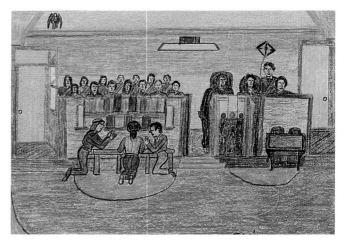

Fig. 5 *Church Interior*, c. 1991, collection of Hillary and Catherine Ahart. This work depicts with accuracy the interior of Kendrick's church chancel down to details such as the light fixtures.

into heavenly and earthly realms. Tacked to the church walls are a few devotional reproductions of the Last Supper and of Christ as the shepherd, crook in hand, guiding his flock (fig. 6). These classic, ubiquitous renderings of Jesus—with long brown hair, pale skin, and a flowing robe with bell-shaped sleeves—are reinterpreted in Kendrick's many presentations of Christ (cat. nos. 5, 6). Each wooden church pew is incised on the end with a simple elongated cross; a similarly defined cross decorates the pulpit front. Kendrick freely used crosses of similar

proportion throughout his work to add a spiritual sense to otherwise secular structures such as oil derricks, towers, and houses (cat. nos. 22, 63).

In subject, Kendrick's earliest extant paintings, from 1977 and 1978, focused on heaven. In these works Christ is set in magnificent, painterly skies, often brushed in thick, curvilinear strokes and occupying a quarter to half the composition. Christ reigns over earth—in full body or bust—with outstretched arms, holding a Bible or walking in the heavens. From this vantage Christ observes earth-

bound individuals, typically depicted at the painting's base, engaged in religious activities: coming to be baptized, going to church, singing in choir, raising their hands to praise the Lord, or reaching toward heaven. Despite Christ's preoccupation with the righteous activities of the humans, there is a clear psychological and artistic separation between heaven and earth.

Some works deal with heaven alone. In these, whether the heavens occupy a small or large part of the overall composition, Christ is given a dominant position as a freestanding, frontally positioned figure, often set against a turbulent, richly colored background. In *Christ with Pink Angels* (cat. no. 9), for example, Christ stands in the central foreground with outstretched arms, his halo and fingertips sparkling with gold, red, and silver glitter. The four-tiered structure to the left, surrounded by rhythmically patterned red and orange swirls, may refer to the mansion in the sky, the heavenly home, cited in John 14:2: "In my Father's house are many mansions: if it were not so, I would have told you. I go to prepare a place for you."

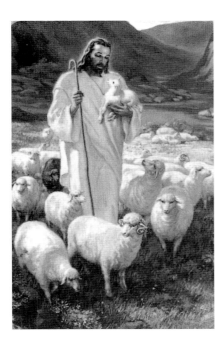

Other early works are more explicit in their rendering of Christ's position as the lord in heaven and his worshipers' place on the earth below. In *Gospel Group and Choir* (cat. no. 5), a graceful Christ, his white robe flowing, descends toward two groups of singers. On the left, gospel singers shout out the chorus of "Oh, How I Love Jesus," and a church choir on the right responds with the refrain from "Stop Now, It's Praying Time," both well-known gospel songs. The words appear in cartoon dialogue balloons coming from individuals' mouths. According to an old African dictum, "the spirit will not descend without song,"[12] and gospel songs are a significant aspect of African-American worship. For Kendrick, both gospel singing and his painting provided avenues for deep spiritual expression. When he created art, Kendrick explained, he "waited on the Holy Spirit."[13]

Kendrick's paintings are replete with references to scripture, both in the form of imagery and as the actual text itself. *Judgment Seat on the Cloud* (cat. no. 6) provides a good example of Kendrick's multilayered scriptural references. The painting seems to exemplify Matthew 25:31–32: "When the Son of man shall come in his glory, and all the holy angels with him, then shall he sit upon the throne of his glory: And before him shall be gathered all nations." Christ descends a golden pathway in the heavens, reflecting the description of the New Jerusalem, the Christian paradise, in Revelation 21:21: "and the street of the city was pure gold." Christ leaves a trail of footprints, drawn in pencil, which recalls the gospel song "Footprints of Jesus": "Footprints of Jesus leading the way; . . . sure if I follow life will be sweet; saved by the prints of His wounded feet."[14] At the painting's lower edge, a row of worshipers dressed in red and yellow-orange shirts lift their arms in praise of God. Directly above them, Kendrick wrote: "Look at the sings [signs] of the judgment in the clouds." He placed these words amid dabs of gray, white, yellow, orange, and black, perhaps illustrating an aspect of Peter's Pentecostal sermon found in Acts 2:19: "And I will shew wonders in heaven above, and signs in the earth beneath; blood, and fire, and vapour of smoke." In small script at

the top left, Kendrick added: "We are going to walk, walk, the milky white way one of these days!" This allusion to the African-American belief that the Milky Way is the path to heaven is reflected in gospel song: "Yes, I'm going to walk, walk that Milky White Way some of these days. . . . I'm going to walk up and take my stand, Going to join, Oh that Christian Band . . ."[15]

To the left of Christ is the chair in which he will sit in judgment of those who wish to enter the kingdom of heaven. Upon it rests an open book in which to record the names of those gaining admittance, as described in Revelation 20:11–12: "And I saw a great white throne, and him that sat on it. . . . And I saw the dead, small and great, stand before God; and the books were opened: . . . and the dead were judged out of those things which were written in the books." Christ holds two sheets lined with writing, the list of those who had earned a place in the eternal book.

*Gospel Group and Choir* and *Judgment Seat on the Cloud* introduce a matrix that Kendrick frequently explored in the 1977–78 works: Christ overseeing the earthly but religiously oriented activities that are central to the black American churchgoing community. For its members, gathering together to worship the Lord is a central element in achieving salvation and eternal life, and by selecting typical and culturally understood symbols of the church—gospel singing, praising God, baptism, churchgoing—Kendrick expressed his own spirituality within the church's ideology.[16]

The ritual of baptism as a symbol of rebirth in the Holy Spirit is an integral part of the road to salvation in Christian churches. For members of the Church of God in Christ like Kendrick, it is one of the most significant religious acts in Christian life. In *Baptism in Front of Buildings with Christ Above* (cat. no. 3), Kendrick portrayed a baptism just as he had seen them: the candidates wear white, hooded robes, and one of them holds the hands of the church pastor and the deacon as they enter the baptismal pool. Set amid a mass of painterly clouds, Christ raises his hands in blessing over the communicants. With a similar

depiction of the heavens, *The Second Coming of Christ! On the Clouds!* (cat. no. 1) brings to mind the scripture of Matthew 24:30: "They shall see the Son of man coming in the clouds of heaven with power and great glory." Just under the clouds at the left, Kendrick suggested the intention of his painting by penciling a subtle inscription in blue: "Get Ready, peoples. To meet. The Lord."

The clear separation between heaven and earth, Christ and the people, is most apparent in *The Second Coming of Christ!* The composition is divided exactly in half, with the top devoted to Christ and the hope for eternal life and the bottom to life on earth. The contrast between the abstract painting style of the heavens and the fine, realistic drawing of buildings, people, and their garments not only demonstrates Kendrick's artistic range but also serves to portray a distinct psychological and physical separation between heaven and earth. In other early works Kendrick achieves this separation in less obvious ways—with a row of buildings (as in *Baptism in Front of Buildings with Christ Above*), a pathway (as in *Judgment Seat on the Cloud*), or a simple abstract line (as in *Gospel Group and Choir,* where it doubles as the suggestion of a cloud). He generally seems to infer that despite the intense desire on both sides to reach one another—for Christ to shepherd his flock and for his righteous followers to attain salvation—they exist in separate worlds that are not easily bridged.

Kendrick consistently depicted Christ with Negroid facial features, but he varied his skin color from rosy pink in *The Second Coming of Christ! On the Clouds!* (cat. no. 1), to a dull gray-white in *The Judgment Seat on the Cloud* (cat. no. 6), to dark brown in *Church of God in Christ* (cat. no. 2) and *We Are Living in the Last Days!* (cat. no. 7). In *Baptism in Front of Buildings with Christ Above* (cat. no. 3), Christ's face is simply outlined in ballpoint pen on a brown faux wood surface, with no added color. Did Kendrick consider Jesus to be a black man or white? His church distributed pictures of both black- and white-skinned Christs,[17] but it is possible that Kendrick, as an ecumenical man bound by the spirit, adopted a view of life and art that transcended race. His depictions of Christ consistently illustrate famil-

iar theological concepts: Christ pointing the way to heaven (cat. no. 2), raising his arms in blessing (cat. no. 8), holding the word of God (cat. no. 10), or beckoning with one outstretched arm, like the shepherd bringing in his flock (cat. no. 34). In a few works, Christ's stance seems to imply the position of his body on the cross, although no crucifix can be seen (cat. no. 11).

Beginning in 1985 Kendrick began to use forms of transportation—trains, airplanes, and boats—as metaphors for the journey of the departed soul to heaven and of a new union between heaven and earth.[18] In some cases Christ pilots the plane or drives the train that collects his righteous passengers; where he does not explicitly appear, he is symbolized by the celestial vehicle. Earthly individuals still appear with upstretched hands, but now they reach not only for the Lord but for the vehicle they hope will deliver them to him (see, e.g., cat. no. 25). With such transitional works, Kendrick finds a new philosophical stance by suggesting the merger of heaven and earth in the transition from mortal to eternal life. His trains and planes give form to the promise of heaven and diagram how an individual might transcend worldly ways to attain salvation at the end of mortal life. Coinciding with his own aging, Kendrick's outlook progressed from a traditional perspective of church and God, bound by the outward manifestations of Christian life (churchgoing, choir singing, baptisms), to a more individualized spirituality. Although still defined by the precepts of his church, this spirituality embraced both inventive personal metaphors and fundamentalist beliefs.

These works also represent a pictorial transition. In them Kendrick introduced a deep, diagonal line cutting from the painting's top to the center, a compositional element seen earlier but infrequently and in shallower form (see, e.g., *Judgment Seat* and *Gospel Group and Choir*). In *Glittery Sky with Boat and Building Below* (cat. no. 21), the first documented work to incorporate this new device, a boat symbolizing the Lord descends from a fabulous painterly sky. Kendrick often labeled such paintings to identify the vehicle and its purpose: "this plane is heaven bound" (cat. no. 23), or "this is the holy train" (cat. no. 26). In works such as *Train from Heaven* (cat. no. 25), the diagonal thrust of the train replaces the more dogmatic separation Kendrick created in earlier works by using a strict horizontal to delineate the line between heaven and earth.

The concept of the train or plane as a symbol for Jesus undoubtedly derived from Kendrick's familiarity with gospel song. Lyrics from a song such as "Jesus Is My Airplane" might have propelled him to render such images as *I Am the Way—Come Fly on Me* (cat. no. 22), in which a stubby plane soars across the sky, its bulbous wings inscribed with the painting's title, which itself derives from John 14:6: "Jesus saith unto him, I am the way, the truth, and the life: no man cometh unto the Father, but by me." In *Heavenly Train,* a work from 1992 (fig. 7), seven small figures look up at a descending train. Cartoon balloons are filled with their words: "Look up." "What is that?" "I don't know." "It's a train." "Lord, help. I want to go." "I got my ticket." The gospel song "The Holy Ghost Special" alludes to such a train ride: "We are on our way to heaven, and don't you want to go? O yes, I want to go! This is the Holy Ghost special, and don't you want to go? O yes I want to go. This train don't carry gamblers, and don't you want to go? . . . This train doesn't carry drunkards, and don't you want to go?"[19]

Kendrick had, of course, a literal familiarity with trains and planes. His home in Higgins lay close to the flight path of airplanes landing at the Little Rock airport, and planes on approach loomed in the sky over the road he traveled into town much as his drawn planes fill the skies in his compositions. In Stephens, near his childhood home, a train track runs one block from the main street. From a nearby bridge, one can see the Union Pacific train take a bend in the track as it emerges from the pines, just the way the celestial rail cars curve through the sky in *This Is the Holy Train* (cat. no. 26). In adult life, Kendrick lived two blocks from the train tracks at Higgins Switch, in Little Rock, which he would have crossed every time he went from home to his church, located just a few blocks on the other side of the tracks.

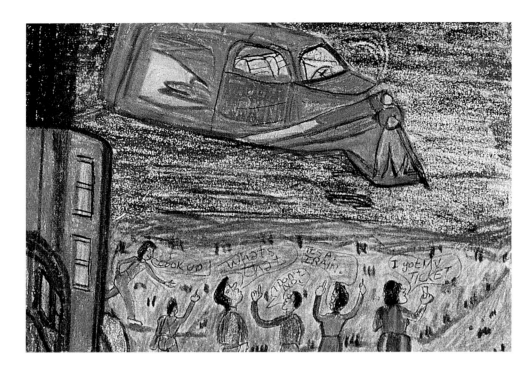

Fig. 7    Detail from *Heavenly Train,* c. 1992, private collection.

At the same time that boats, trains, and airplanes made their appearance in Kendrick's work, the artist introduced a new symbol, the bird, for the Holy Spirit, as seen, for example, in *Bird over Landscape with the Eye of God Above* (cat. no. 28). In this and *Bird in Wintry Blue Landscape* (cat. no. 27), he gave a literal rendering of scripture (and his church's authority) by depicting the bird clutching a stone in its talons, the stone inscribed with the word "God." In the latter painting, faintly seen between the wings of the bird is the letter "G." Kendrick's inspiration might have been Matthew 3:16: "And Jesus, when he was baptized, went up straightway out of the water: and, lo, the heavens were opened unto him, and he saw the Spirit of God descending like a dove, and lighting upon him." Another interesting interpretation points to John 1:1: "In the beginning was the Word, and the Word was with God, and the Word was God."

Central to understanding Kendrick's spiritual views and his artwork is the New Testament Book of Revelation. This apocalyptic document is filled with visions, symbols, and allegories relating to the end of the world and the Last Judgment, when all the dead will rise and Christians will live in their new paradise on earth, the New Jerusalem. Revelation 21:2 describes "the holy city, new Jerusalem, coming down from God out of heaven." In *City Coming Down with Bird Descending* (cat. no. 29), a bird,[20] symbol of the Holy Spirit, flies toward the earth, a colorful city in the background. In an inscription—"city coming down"—Kendrick tells us that this subject represents the heavenly city of Jerusalem, coming down to earth.[21]

Interestingly, while depicting this fulfillment of the scriptures in Revelation in these paintings, Kendrick in other works largely removed Christ from the heavens and clouds that symbolized his Second Coming. The skies remain beautiful, with a touch of abstract painterliness, but are minimized and no longer carry their earlier meaning. Many paintings from 1991 and 1992 are set on earth and focus on seemingly secular themes such as fantastic architecture and rural daily life. But subtly placed symbols recur—angels (singly or as heavenly hosts), eyes of God, storm clouds, light emanating from buildings, candles, and halos. These symbols take the place of actual representations of Christ, and many can be linked to scripture,

reminding the careful viewer of Kendrick's continued religiosity. Light sources, for example, illustrate the concept of Christ as the "light of the world" (John 8:12). *Landscape Eye of God and Dark Clouds* (cat. no. 42) is predominately a scene of daily country life, with men fishing and chatting. But troubled black clouds loom in the sky, and they part to reveal a watchful eye of God (fig. 8), recalling Proverbs 15:3: "The eyes of the Lord are in every place, beholding the evil and the good." The sun tucked behind the dark clouds summons Isaiah 60:19: "The sun shall be no more thy light by day; . . . the Lord shall be unto thee an everlasting light."

Kendrick usually portrayed an angel, some more conspicuous than others, in most of his later works (fig. 9). He believed in guardian angels, and a friend remembers that Kendrick explained that he would put a small angel somewhere in a painting for the viewer to discover.[22] In one work, he clustered an entire host of angels in the sky (see cat. no. 13) and identified them as the angels who "watch over us day and night."

In addition to his new range of symbols, Kendrick increasingly gave compositional focus to large written texts to bear his message. Kendrick had always used text in tandem with imagery to advance his meaning and as a design element. But where it had once been subtle, small, and unobtrusively integrated into a composition, text in the later works appears in large, significant block letters, outlined in black (fig. 10). In the transitional *I Will Lift Up My Eyes to the Hill* (cat. no. 31), the words are large and bold, but they lace through the composition, their colors coordinated with the background. Eventually Kendrick allowed his message to dominate the picture by placing powerfully outlined letters against a pale blue sky that might occupy half or more of the picture. He admonished the viewer: "Let not your heart be trouble[d] at no time. Stay with Jesus" (cat. no. 32), or "Come try Jesus. Come on he can save you" (cat. no. 30). These sayings derive from biblical scripture, folk sayings, and the evangelistic signs that once dotted the rural southern landscape (fig. 11). Filled in with contrasting colors, the block letters stand out from the background, and the message literally takes the place that the messenger, Jesus, once held at the top center of his compositions.

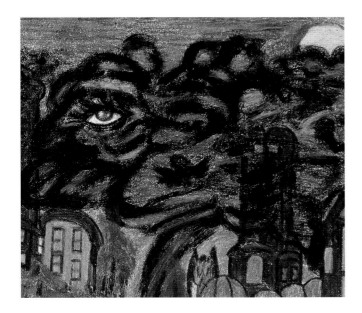

Fig. 8   Detail from *Landscape Eye of God and Dark Clouds* (cat. no. 42)

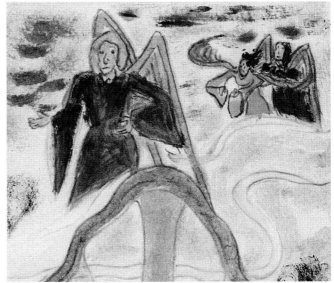

Fig. 9   Detail from *The Judgment Seat on the Cloud* (cat. no. 6)

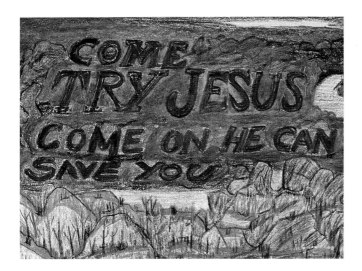

Fig. 10   Detail from cat. no. 30 showing Kendrick's characteristic block letters and the impact of evangelical signs in the landscape on his imagery.

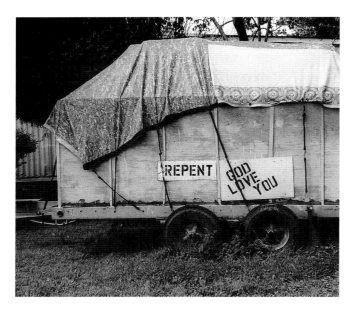

Fig. 11   Evangelist's trailer/sign, near Sweet Home, Arkansas, 1998. Photo: Susan Turner Purvis.

The later works also carry abundant autobiographical elements related to the Arkansas landscape: fishing scenes; the many oil and forestry towers that dotted the area of his childhood home near Stephens; rural cottages like an early family home; and images reminiscent of country life. Most dramatically, architecture took a central position, from combinations of elements taken from actual buildings that Kendrick saw around him to wholly imagined structures. While his ability to render architectural structures was superb, Kendrick rarely tried to draw buildings precisely as they appeared.[23] Just as he would blend elements from his life history into one composition, he projected elements of one building onto another, and then added his own imaginative twist of color, shape, or design. He took a special interest in showing front elevations, cornices, side views, and facades punctuated by unusual windows and doors. At first, such buildings seem to have little connection to Kendrick's immediate surroundings. But a sharp eye will see that they are informed by the varied styles he saw in Little Rock: flat-roofed buildings, square or rectangular flat commercial storefronts, rounded and intricate Victorian homes, contemporary high rises, skywalks, and split-level suburban homes.

Curvilinear, multiplanar, and convoluted, his structures create an interesting sense of depth and irregularity of space. Kendrick took the typical elements of a building—staircases, windows, doors, courtyards, arches—and fully exploited their perspectival value. This practice culminated in works like *U-Shaped Building with Three Men on a Bench* (fig. 12), in which he aligned the building facades themselves into a courtyard that draws the viewer into the picture plane. What was once a path leading the eye to a building exterior is now an interior courtyard of a building itself. Kendrick may have struggled with occasional frustration at not achieving architectural precision in his use of perspective, but he clearly matured in his ability, as seen in the many points of conflicting perspective in a work such as *Baptism in Front of Buildings with Christ Above* (cat. no. 3) to the one-point perspective of *U-Shaped Building* or *This Is the Holy Train* (cat. no. 26). He created areas

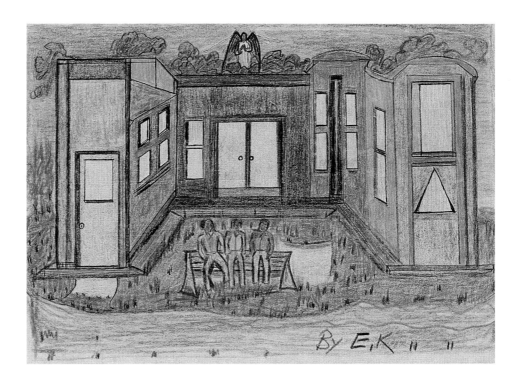

Fig. 12 *U-Shaped Building with Three Men on a Bench,* c. 1992, private collection. This painting shows Kendrick's accomplished use of perspective.

of depth even in a work like *Let Not Your Heart Be Troubled at No Time* (cat. no. 32), with its fairly flat surface, by taking full advantage of the architectural features of a group of small but magnificent buildings. Kendrick also developed an interest in dissecting buildings, placing, for example, a heart shape in the middle of one (cat. no. 39), or sectioning a facade to reveal interior rooms, as in *A Bed in the Sun* (cat. no. 41).

While the architecture fulfilled Kendrick's natural inclination to create depth and small passageways for the eye to visit, it had a more important philosophical meaning in works such as *City Coming Down with Bird Descending* (cat. no. 29), whose colorful, futuristic structures most likely depict the heavenly city of New Jerusalem, or *Revelation 17:18* (cat. no. 44), which Kendrick described to a friend as "the new city of Jerusalem."[24] How many of Kendrick's later works might portray the New Jerusalem, a heaven on earth, is unknown. But many of them are complete, even serene works that express unity in a physical and spiritual sense.

In his later works Kendrick also developed a series of structures with a rich and varied fenestration that suffused

his paintings with light. Beginning in 1992, doors and windows—which earlier had remained fairly closed—took on the jewel tones of a new luminosity. The effect calls to mind the appearance of window light seen in assorted shapes and sizes in the dark of a country night. This focus on light shining from within coincided with Kendrick's development of light sources as symbols of the omniscient Lord, and light now took the place of glitter to suggest spiritually imbued spaces. The abundance of light radiating from varied sources—windows, doors, candles, lampposts, chandeliers, and spotlights on exteriors—reflects the sentiments of scriptural passages such as "Thy word is a lamp unto my feet, and a light unto my path" (Psalm 119:105) or, Kendrick's favorite, "The Lord is my light and my salvation" (Psalm 27). In this sense, his artistic development paralleled and was nurtured by his spiritual growth.

Kendrick often visualized reminiscences of his past by conflating elements from rural and urban Arkansas. In many works, oil derricks, fishing ponds, and small town commercial storefronts stand beside urban buildings drawn from the streets of Little Rock. From the natural landscape one sees abundant bodies of water, tall autumn

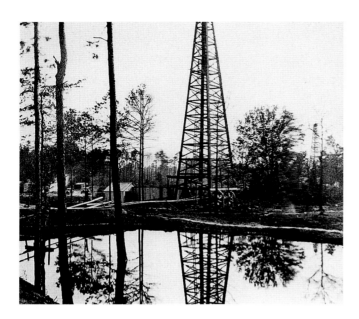

Fig. 13   Oil well near Stephens, Arkansas, early 1920s. Courtesy Arkansas History Commission.

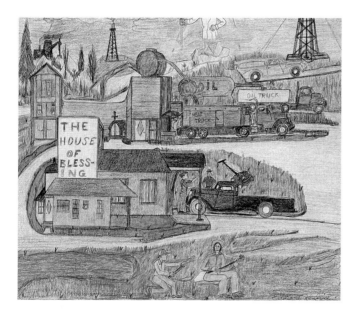

Fig. 14   Detail from cat. no. 63 showing Kendrick's vignette style.

grasses amid smaller green clumps, jagged rocky hills, the plowed earth, and stands of pine trees. All these elements surrounded Kendrick in his daily life, and he carefully incorporated them into his works. For a foreground he might use linear, staccato strokes of green, brown, and black pencil to create smooth beds of grass, accented with higher, uneven clumps of a darker color, strikingly evoking the look and feel of his Arkansas environs (see cat. no. 30). Jagged rocks recall the hills around Little Rock, particularly the bluff on the north shore of the Arkansas River, surmounted by old Fort Roots (see, e.g., *These Are Angels That Watch over Us Day and Night,* cat. no. 13). Small bodies of water, streams, and ponds interlace the pine-treed landscape of southwest Arkansas. Frequently such pools sit immediately off a highway, in just the same relationship to surrounding pastures and buildings as found in Kendrick's works, where compositionally—as ponds, baptismal pools, or fishing holes—they give depth by visually distancing the picture plane.

Kendrick's environs were filled with towers—oil derricks, communication towers, forestry towers, and railroad signals—and they are a repeated feature in his works. Upon many of them, one finds delicate, narrow, elongated crosses (much like those seen in Kendrick's own church, carved into the sides of the pews). These crosses applied to towers and houses made even the most secular spaces sacred. Towering church steeples point toward heaven and God, sometimes stretching to the top of a composition to visually connect earth with heaven. Towers themselves—in varying guises ranging from a glittery spire in a church, a rocket in the air, to an obelisk—served as actual conduits between heaven and earth (cat. nos. 2, 20, 52).

Oil had been discovered near Stephens in 1921, and the sound and sight of a single oil pump working amid a grove of pine trees was another common scene (fig. 13). Other familiar sites were cotton hoeing and disking (cat. no. 57), and fishing (cat. no. 58). Kendrick often sketched small, barely noticeable vignettes reflecting these aspects of rural life into works devoted to other themes (fig. 14).

It is in his later works that Kendrick made specific reference to the dreams that he stated were an influence on his imagery. Unlike references to gospel music and scripture, which can be somewhat objectively linked to Kendrick's paintings, his dreams were purely personal and for the most part undocumented. But they clearly were a powerful source of inspiration and perhaps imagery. Kendrick reported to some friends that dreams and visions inspired him, and he once said: "I draw about what I dream. When it comes to me real plain, I'm going to draw it."[25] Once Kendrick dreamed about a bird and sketched it, and later in the same day, made a finished drawing of it. Other such sketches in the Kendrick family collection also appear to be linked to completed works.[26]

Kendrick overtly referred to his dreams in only a few works. In *My Dream* (cat. no. 59), a simple pink cottage is dwarfed by the scaffolding of a refinery. Both of these buildings recall structures Kendrick knew well. Refineries punctuated the Arkansas landscape, and the cottage, narrow bodied and with a pitched roof, is a familiar sharecropper or tenant farmer dwelling, similar to the homes of his sister and mother (fig. 15). A man walks in the air, seemingly passing from the inscribed words "coming from southwest" to "going to northeast." The juxtaposi-tion of these elements recalls the Kendrick family's move in the mid-1940s from southwest to northeast Arkansas, from the countryside to city environs.

In another work, a simple drawing on a piece of lined paper (fig. 16), Kendrick drew two intertwined snakes and above them wrote: "My dream about snakes. Too [two] for one. These or [are] my enemis [enemies]." The dream about snakes suggests a struggle against evil, the snake representing the enemy of right living.

Without documentation, however, the interpretation of dream imagery is highly subjective. But it can be said that there is an interesting relationship between the structure of Kendrick's work and that of dreams, in which images, ideas, and emotions are layered regardless of place or time. *House of Blessing* (cat. no. 63), for example, peacefully unites physical objects that document all the stages of Kendrick's life. From his early life come a pink cottage, the "house of blessing," pine trees, and oil derricks. These are merged with city buildings and trucks, including a meat truck, references to Kendrick's longtime employment in Little Rock at the Brown Packing Company. In the heavens stands a smiling angel with a shepherd's crook; a banner flying from a lamppost proclaims, "The Lord is my shepherd." An airplane flies above, not on a

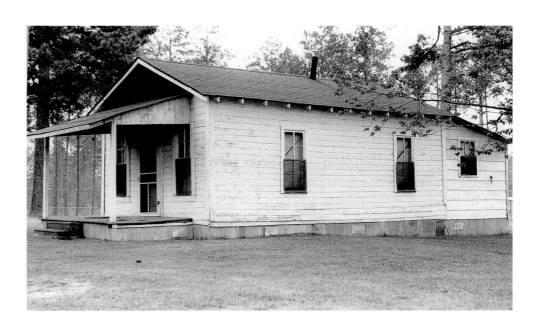

Fig. 15   Rural cottage near
Stephens, Arkansas, 1998.
Photo: Susan Turner Purvis.

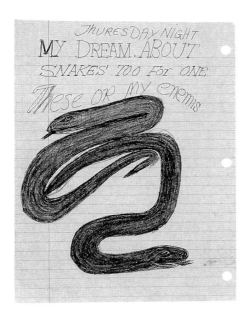

Fig. 16    *My Dream about Snakes,* 1991–92,
Collection of the Kendrick Family.

diagonal like Kendrick's salvation-bound vehicles, but in a straight line, causing one to think that in this work heaven and earth are one.[27] Kendrick, perhaps, depicted heaven with elements from the earth he knew, much in the way a dream brings together the real and the imagined.

Kendrick deeply believed in the power of prayer, and when painful signs of his own cancer developed in 1991, he did not seek medical treatment until the disease had greatly advanced. Even as his illness progressed, he referred to his belief in the Lord as his healer in the inscriptions to work from his last years: "About your Lord and my Lord: He is a doctor in a sick room. He is medicine" and "I need Jesus, I need Jesus . . . He brought me through 1991, all [the] way to 1992."

Kendrick died on November 23, 1992. His funeral pamphlet contained two verses Kendrick wrote, and they stand, with his paintings, as powerful testimony to his abiding and deep relationship to the Lord.

Early in the morning
When the sun began to shine
When I look at the moon
The stars in the sky
I can see the hand of the Father
In the valley so deep
And in the river so wide
Early in the morning
When the sun shine so
I can feel the hand of the Father
Touching me.

♪    ♪    ♪

I'm so glad I learned
How to depend on Jesus
So many times
My friends let me down
But Jesus never failed me
Help me say this "Sister Parker"
Thank you, Jesus, thank you Jesus
I learned how to lean
And depend on Jesus
I found out if I trust him
He will provide
He's my friend
And he's my guide

—Eddie Kendrick

## Notes

Interviews with members of the Kendrick family supplied much of the material relating to Kendrick's biography.

1. One example of Kendrick's use of corrugated cardboard is *Rippled Landscape* (cat. no. 54). The corrugated board, tempera paint, crayon, and hosts of outlined angels point to a date of 1977–78, but the absence of a Christ figure, the mountainous landscape, and the use of oil and colored pencil suggest that Kendrick completed the work much later.

2. Edwin Scott Gaustad, *A History of Religious America* (San Francisco: Harper, 1990), p. 187. Membership in the Church of God in Christ grew 863% from 1967 to 1977 (Russell Shorto, "Belief by the Numbers," *New York Times Magazine*, December 7, 1997, p. 60).

3. Kendrick did engage in healing the body using olive oil, as referred to in scripture. According to his niece Alma Smith and his sister Darlene Deadmon, he would rub the afflicted area with blessed oils and pray (interviews by Susan Turner Purvis and Alice Rae Yelen, September 1995 and October 1997).

4. Howard Finster and William Edmondson, for example, both indicated that the Lord instructed them to paint.

5. Eddie Kendrick, interview by Susan Turner Purvis, February 1991.

6. Ibid.

7. Ibid.

8. Elton Kendrick, interview by Alice Rae Yelen, May 1997.

9. Following Kaplan's advice, Kendrick began signing and dating his paintings, but he did not maintain either practice. Only a few early works bear dates, and signatures exist on about half his documented works. Signatures most often appear in the lower right, in cursive script, block letters, or a combination of the two. He variously signed his name "Eddie Kendrick" or "E. Kendrick," and occasionally used his initials.

10. Nancy McDonough, interview by Alice Rae Yelen, April 1998.

11. Kendrick took these words from the title of a gospel song.

12. William McClain, *Songs of Zion* (Nashville: Abingbon Press, 1981), pp. ix–xi.

13. Eddie Kendrick, interview by Susan Turner Purvis, February 1988.

14. *Big Five Sweet Wonder Special Song Book* (Los Angeles: Wonder Books, n.d.), p. 95.

15. Ibid., p. 81.

16. McClain, *Songs of Zion,* pp. ix–xi.

17. Rev. R. N. Sanders, interview by Alice Rae Yelen, May 1998. These materials came from the Church of God in Christ headquarters in Memphis, Tennessee.

18. Kendrick is not the only self-taught artist to incorporate celestial transportation to his art imagery. Sister Gertrude Morgan is well-known for her works of airplanes taking her to the New Jerusalem as the bride of Christ. "Jesus Is My Airplane," which is written as descriptive text on an artwork, is also the epithet on her gravestone.

19. *Big Five Song Book,* p. 120.

20. While scriptures refer to the Holy Spirit as a dove, Eddie's drawing looks more like an eagle. In *Bird in Wintry Blue Landscape* (cat no. 27), the bird's face and the upright position of the body and wings, reminiscent of the eagle on the dollar bill, suggest that Kendrick took the form of this bird from popular culture.

21. An interesting link perhaps exists between the description of the foundations of the wall of the New Jerusalem as "garnished with all means of precious stones" and Kendrick's color choices. The stones jasper, sapphire, emerald, topaz, and jacinth, for example, are paralleled in the colors red, blue, green, pink, and violet—all of which figure in Kendrick's palette.

22. Susie Robinson, conversation with Susan Turner Purvis, August 1995. Robinson also recalled that Kendrick stated he would not paint in the schools if, because of the separation of church and state, he was not able to paint his angels. No such suggestion was made to him (interview by Alice Rae Yelen, May 1997).

23. Kendrick in at least one instance painted a simplified church facade reminiscent of the common twin-towered gable form seen in small southern towns (cat. no. 3) and years later abstracted the form (cat. no. 44).

24. Melverue Abraham (a self-taught artist and friend of Kendrick's), interview by Alice Rae Yelen, May 1998.

25. *Arkansas Gazette,* March 13, 1977, p. D2.

26. Sketches from the family's collection appear to correlate to *Bird in Wintry Blue Landscape* (cat. no. 27) and *Bird over Landscape with the Eye of God Above* (cat. no. 28).

27. In several works from 1992, Kendrick included boats with a similar quietude that appear docked, stationary and peaceful, implying a similar sense of a journey accomplished.

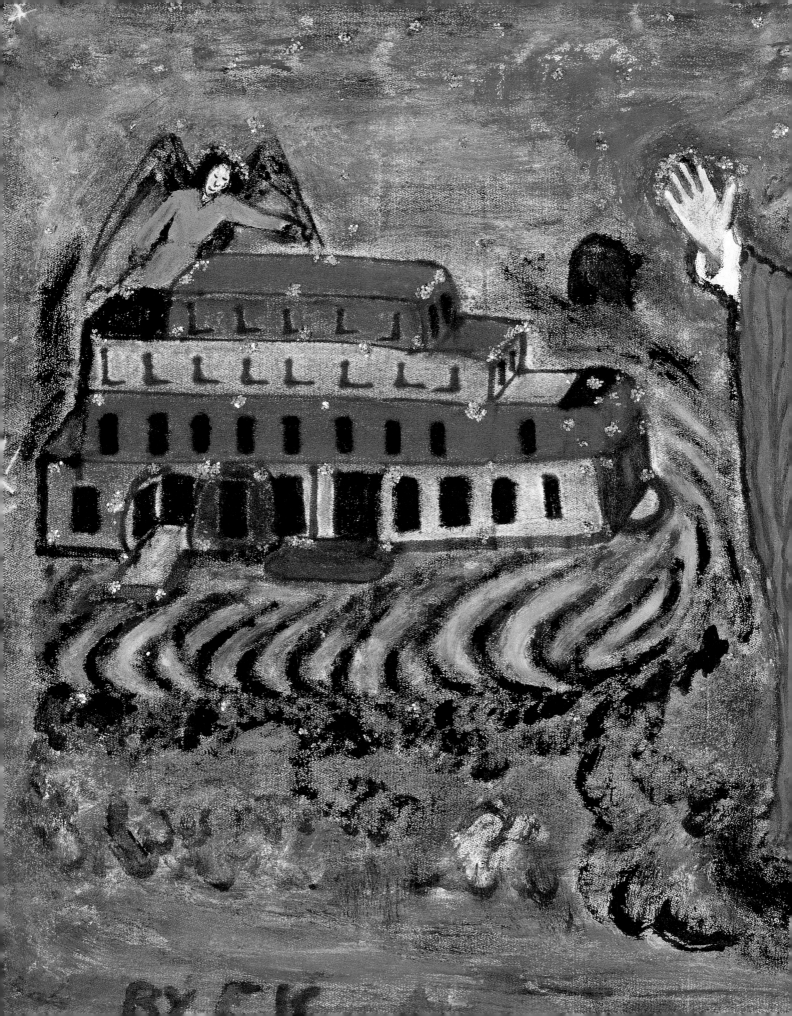

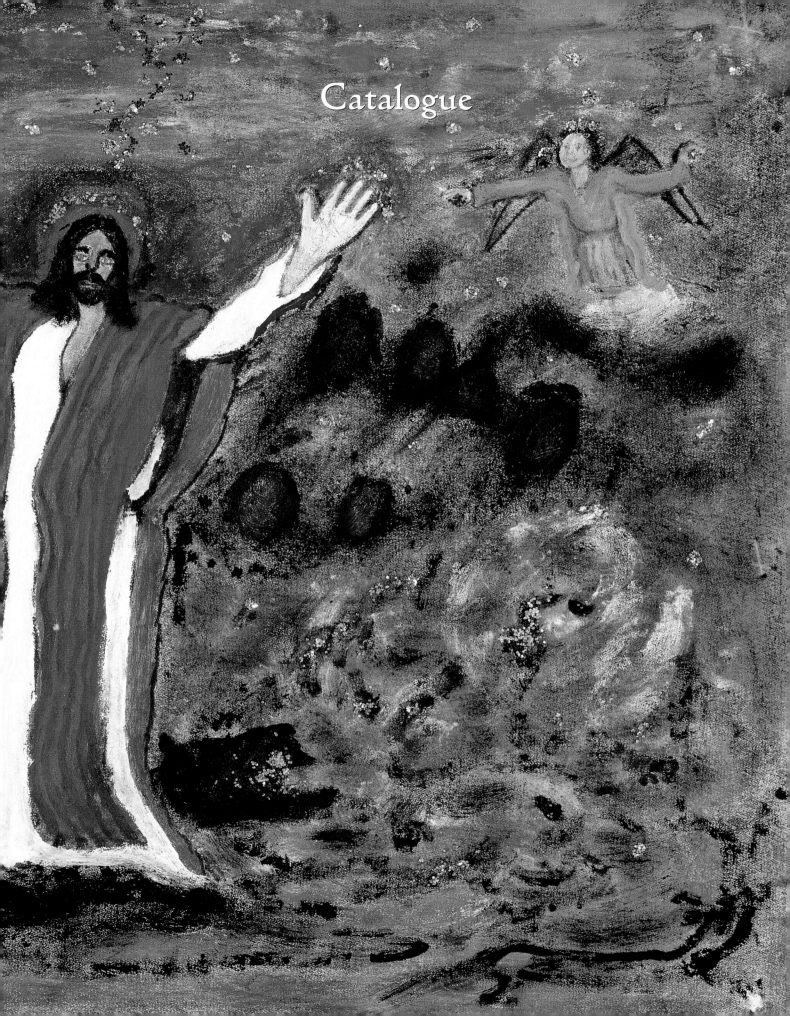

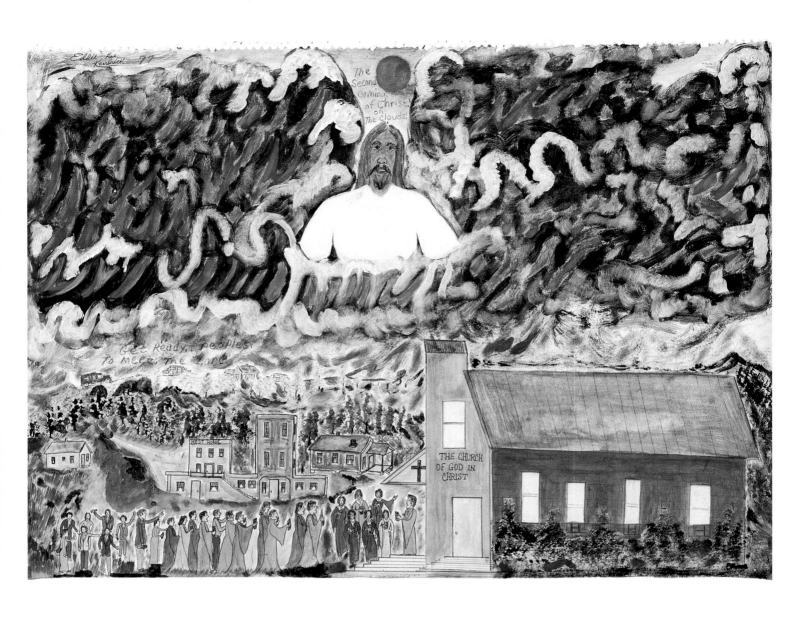

**1**

*The Second Coming of Christ! On the Clouds!*, dated 1977
Acrylic, ballpoint pen, colored pencil, and pencil on paper
17⅝ × 24 in. (45.4 × 61 cm)
Collection of Bill Hawes

**2**

*Church of God in Christ,* dated 7/30/78
Acrylic, marker, ballpoint pen, glitter, and glue
on synthetic, open-weave fabric
24 × 29¾ in. (61 × 75.6 cm)
Collection of Louise Bloom

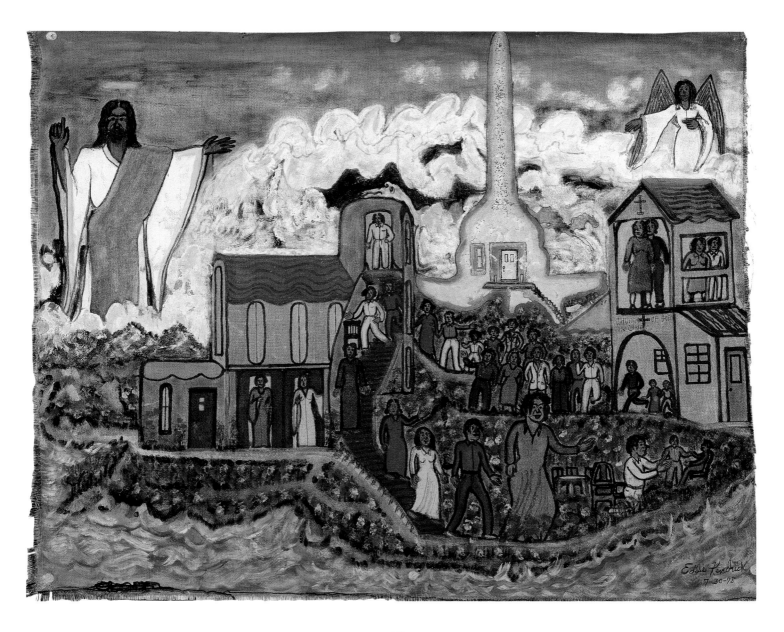

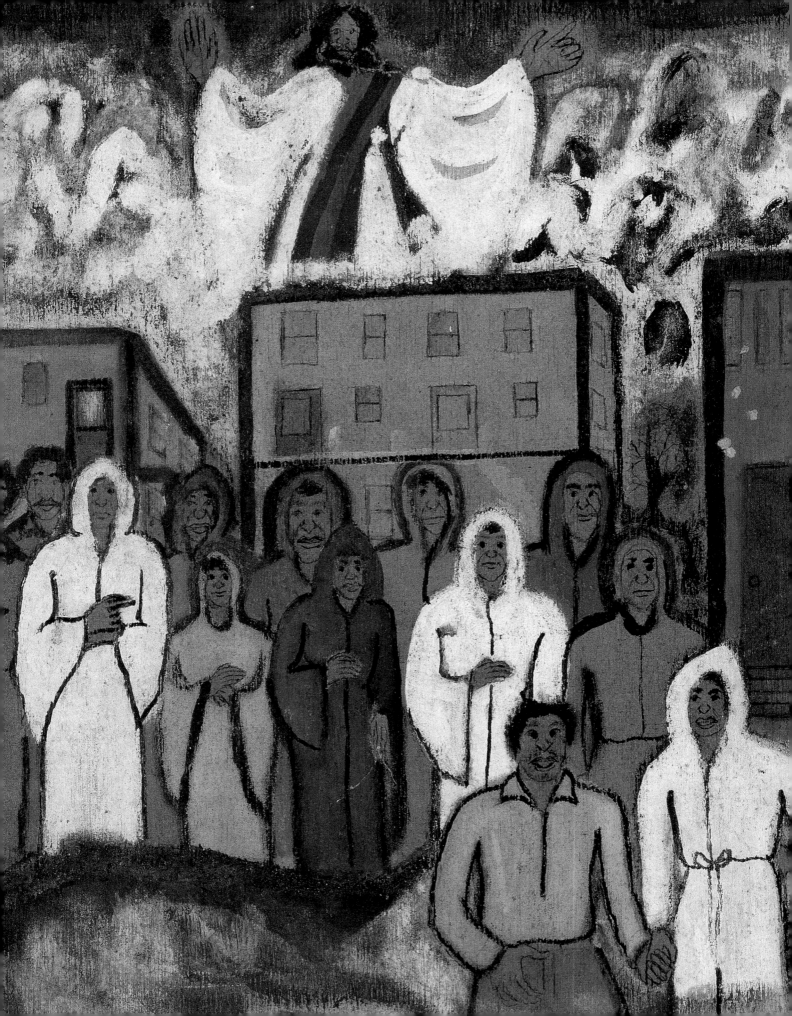

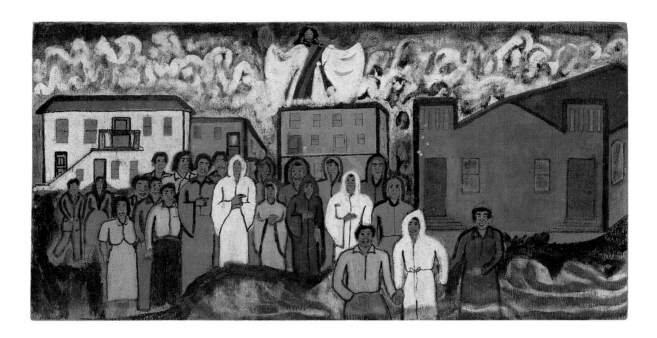

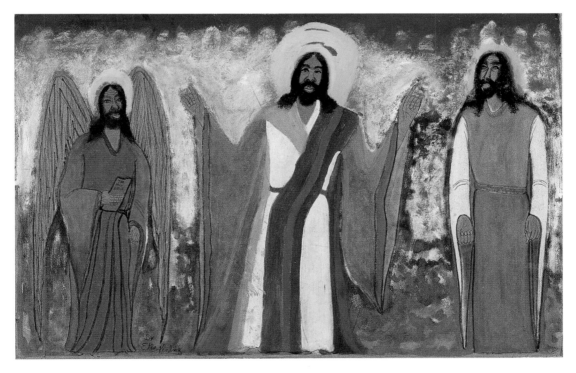

3
*Baptism in Front of Buildings with Christ Above*, c. 1978
Acrylic and ballpoint pen on paperboard
with faux wood grain on reverse
15½ × 29¾ in. (39.3 × 75.5 cm)
Private collection

4
*Trio of Religious Figures*, c. 1978
Acrylic, marker, and ballpoint pen on cork
mounted on corrugated cardboard
23¾ × 36 in. (60.4 × 91.5 cm)
Private collection

**5**
*Gospel Group and Choir*, c. 1978
Acrylic, ballpoint pen, and pencil on manila paper
mounted on posterboard and laminated
9⅜ × 12½ in. (23.8 × 31.8 cm)
Collection of Louise Bloom

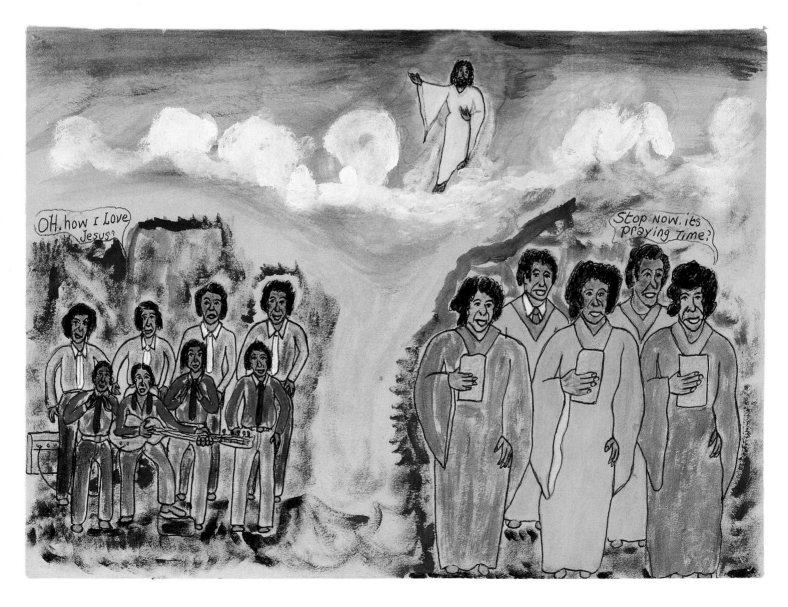

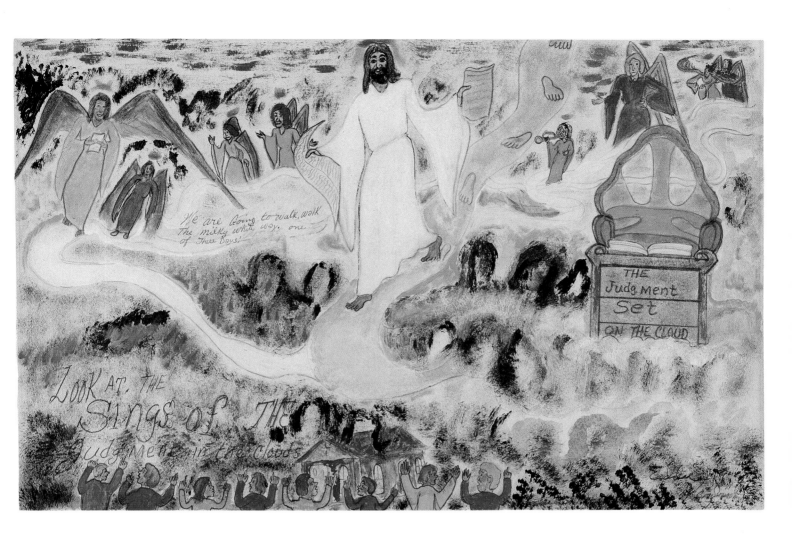

6

*The Judgment Seat on the Cloud,* dated 1978
Acrylic, pencil, colored pencil, and ballpoint pen on paper
12 × 18¼ in. (30.5 × 46.4 cm)
Collection of Elizabeth G. Purvis

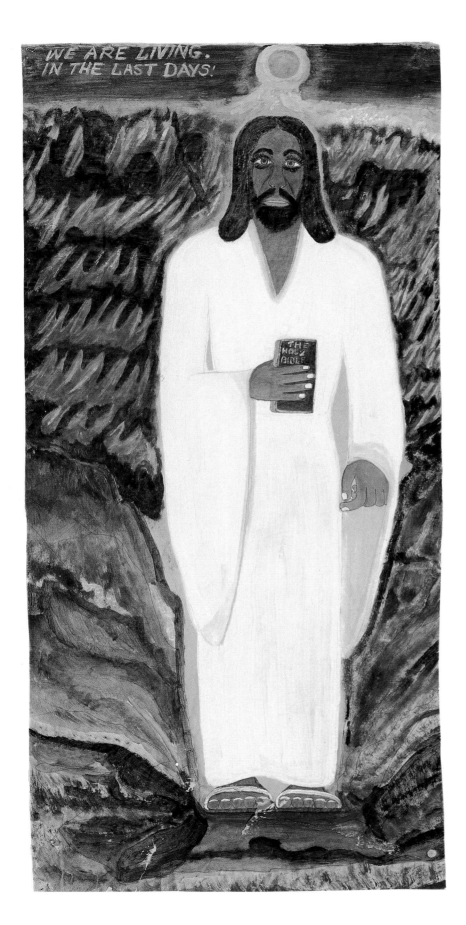

**7**
*We Are Living in the Last Days!*, c. 1978
Acrylic, ballpoint pen, and pencil on paper
mounted on paper
43¼ × 20½ in. (109.9 × 52.0 cm)
Collection of Louise Bloom

**8**
*Small Image of Christ in Red and Green*, c. 1978
Acrylic and ballpoint pen on synthetic,
open-weave fabric
14 × 11 in. (35.6 × 27.9 cm)
Collection of DeVonie L. Cunning

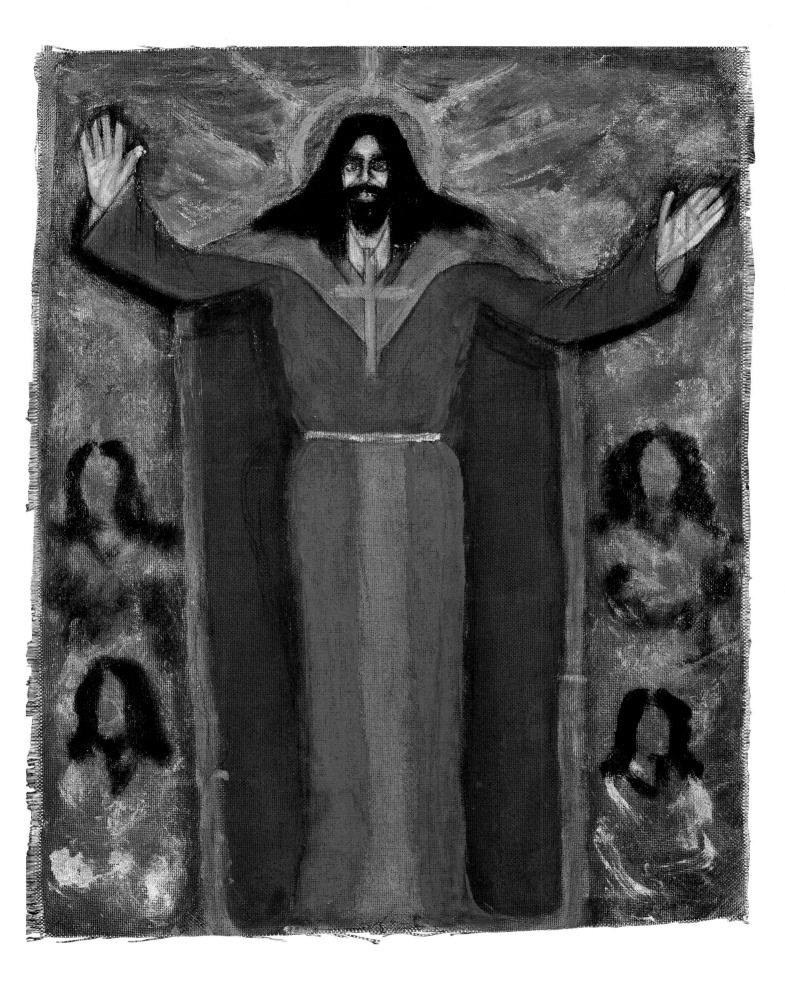

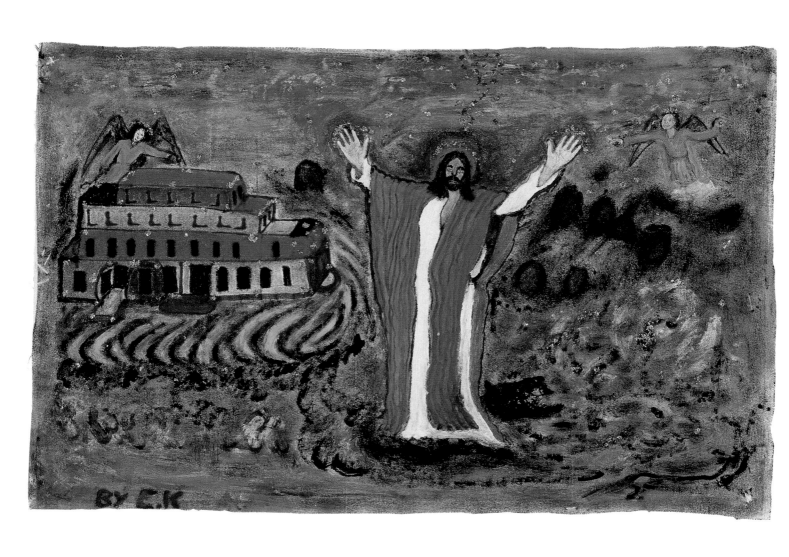

9
*Christ with Pink Angels,* c. 1985
Acrylic, oil, marker, glitter, and glue on fabric
18⅝ × 28½ in. (47.3 × 72.4 cm)
Collection of Nancy and Russ McDonough

**10**

*Christ in Boat over Green Roofs*, c. 1985
Oil, acrylic, ballpoint pen, glitter,
and glue on fabric
21¼ × 21¼ in. (54.0 × 54.0 cm)
Collection of McDowell and
Mary Nell Turner

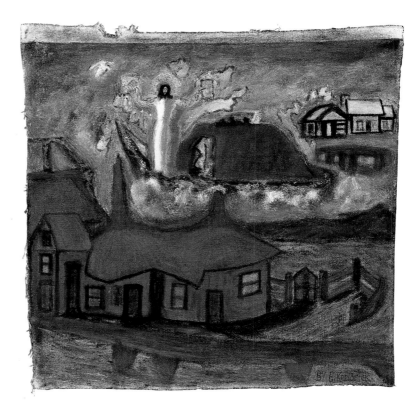

**11**

*Christ with Reflection in Water*, c. 1991
Water-based paint, colored pencil,
and ballpoint pen on paper
12 × 18 in. (30.5 × 45.7 cm)
Collection of Corrie White

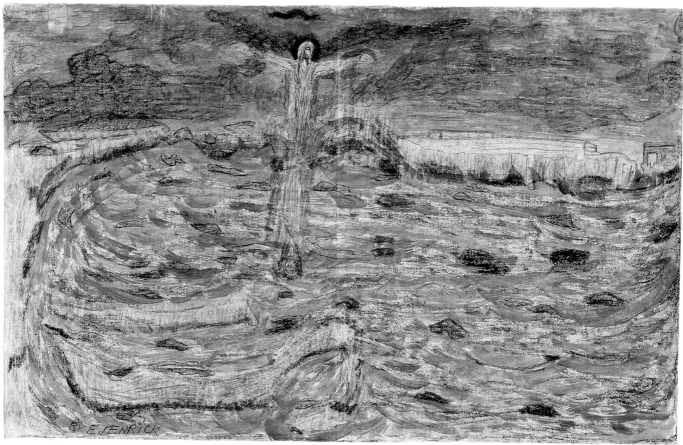

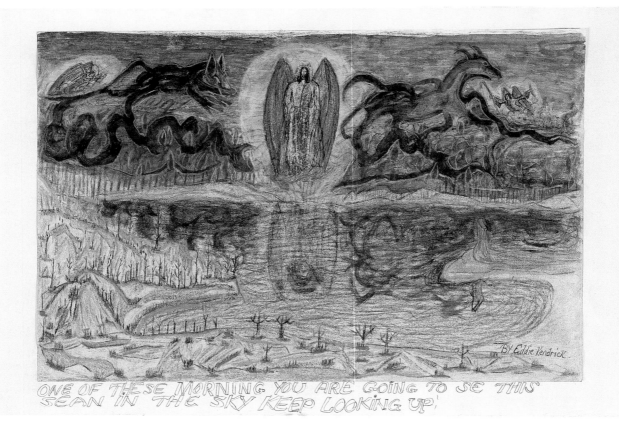

ONE OF THESE MORNING YOU ARE GOING TO SE THIS
SEAN IN THE SKY KEEP LOOKING UP'

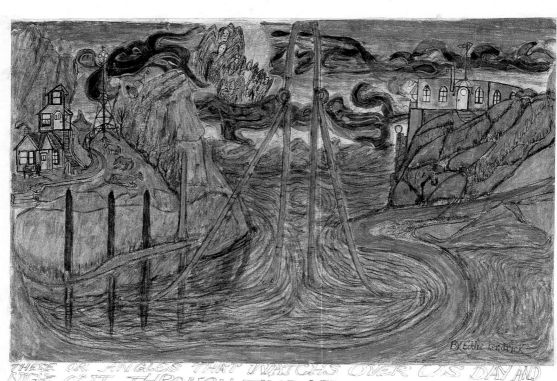

THESE OR ANGLES THAT WATCHS OVER US DAY AND
NIGHT OUT THROUGH TIME. I TELL YOU WHEN YOU ENTIR

**12**

*Christ Surrounded by Beasts,* c. 1991
Water-based paint, colored pencil, and ballpoint
pen on paper mounted on posterboard
14 × 22⅛ in. (35.6 × 56.2 cm)
Collection of Benjamin H. T. Purvis

**13**

*These Are Angels That Watch over
Us Day and Night,* c. 1991
Water-based paint, ballpoint pen, and colored
pencil on paper mounted on posterboard
14⅛ × 22⅛ in. (35.9 × 56.2 cm)
The Arkansas Arts Center, gift of
Kayren Grayson Baker, 95.28

**14**

*Turn and Go the Right Way,* c. 1991
Water-based paint, colored pencil, and ballpoint pen
on paper mounted on posterboard
13⅞ × 22 in. (35.2 × 55.8 cm)
Collection of Tim Goetz

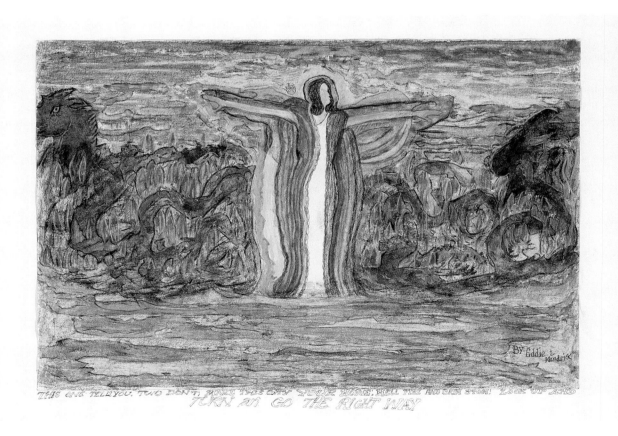

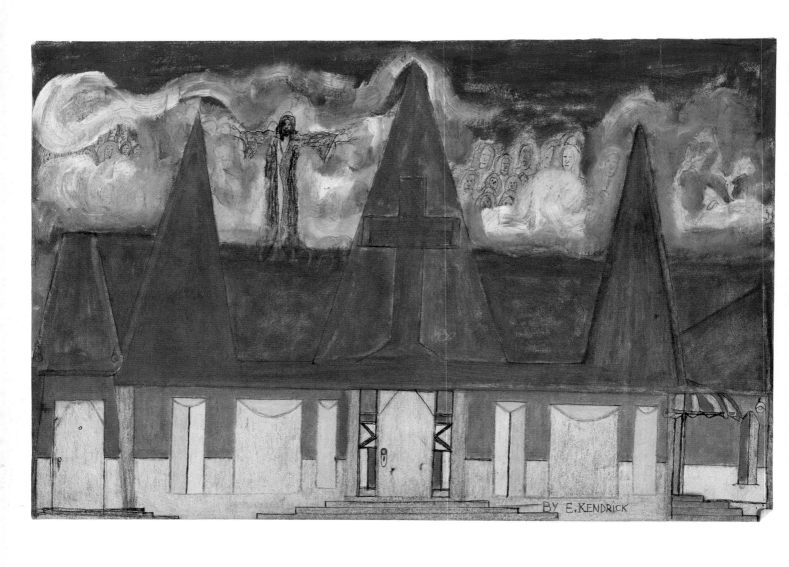

**15**

*Church with Roof and Christ Above*, c. 1991

Oil, colored pencil, and ballpoint pen on paper

12 × 18 in. (30.5 × 45.7 cm)

Collection of Patrick Cowan

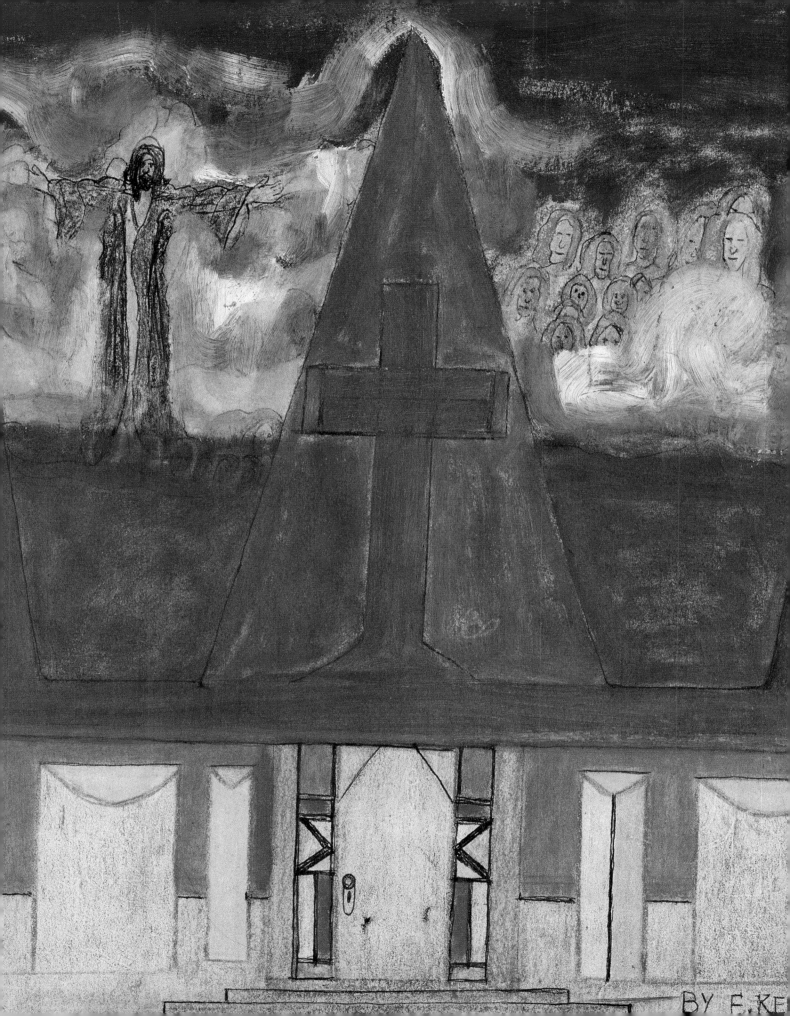

BY F. KE

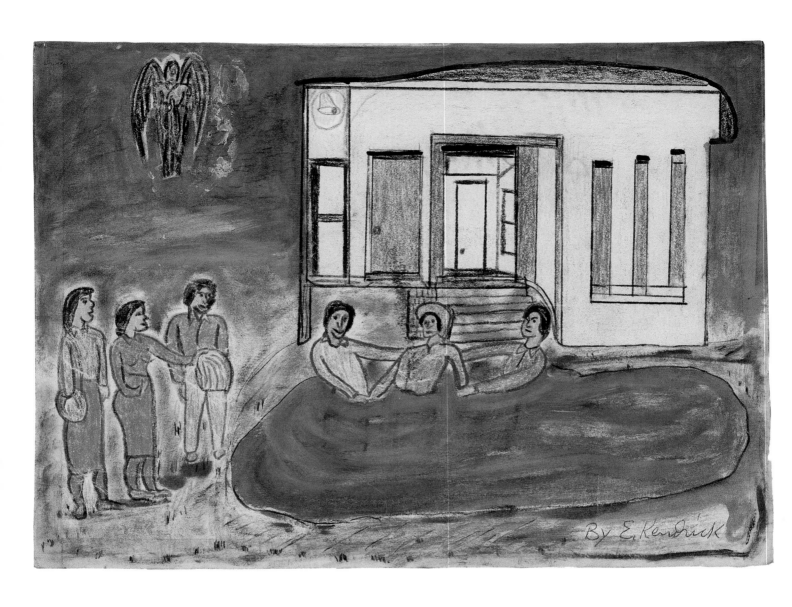

16

*Baptism in Front of White Building*, c. 1991

Oil, colored pencil, and ballpoint pen on paper

9 × 12 in. (22.9 × 30.5 cm)

Collection of Lashanda Allison

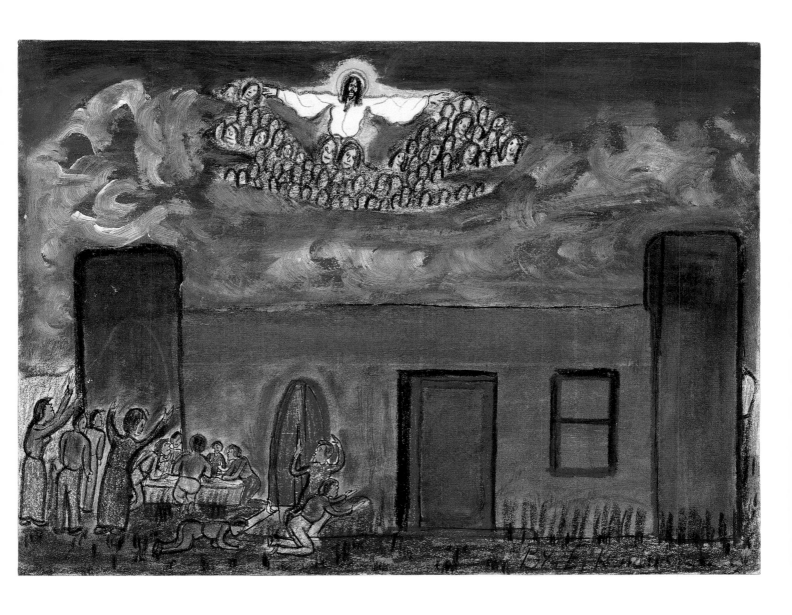

**17**

*Red Building with Cluster of Heavenly Hosts Above,* c. 1991
Oil, acrylic, colored pencil, and ballpoint pen on paper
9 × 12 in. (22.9 × 30.5 cm)
Collection of Evita A. Washington

18
*Woods Temple Church of God in Christ Interior*, c. 1992
Colored pencil, oil, pencil, and ballpoint pen on paper
12 × 18 in. (30.5 × 45.7 cm)
Private collection

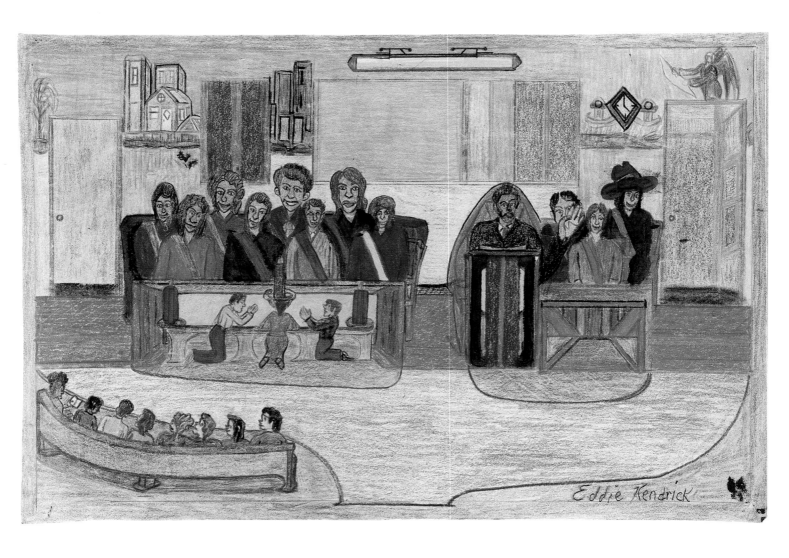

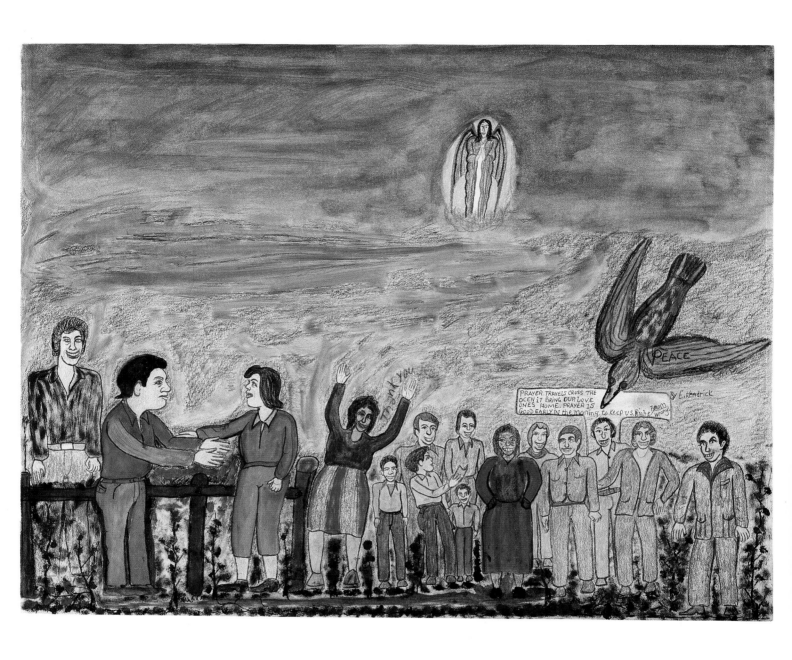

19
*Prayer Travels across the Ocean,* c. 1991
Oil, colored pencil, pencil, and ballpoint pen on paper
19 × 24 in. (48.2 × 58.4 cm)
The Arkansas Arts Center, given on behalf of Kids for Peace,
Children of Gibbs Magnet School, 94.55

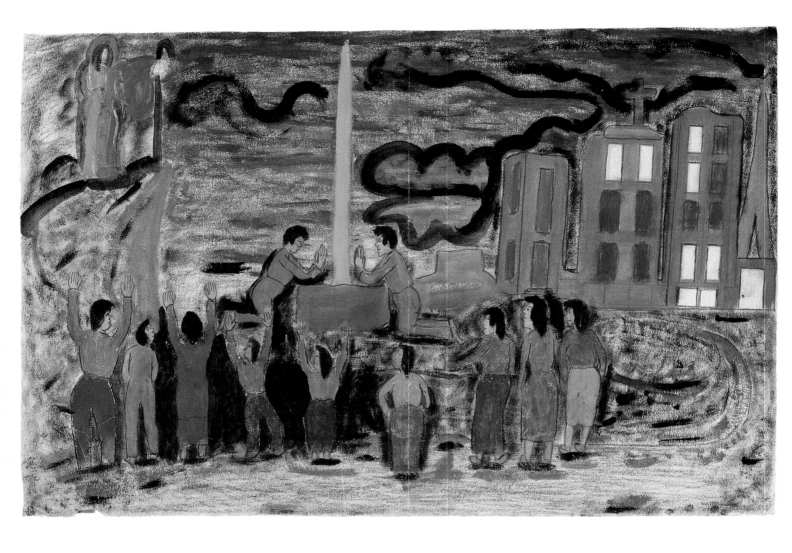

**20**

*Worshiping Outside,* c. 1991

Oil, colored pencil, and ballpoint pen on paper

12 × 18 in. (30.5 × 45.7 cm)

Collection of Tiffany C. Cravens

**21**

*Glittery Sky with Boat and Building Below,* c. 1985

Acrylic, oil, colored pencil, marker, glitter, and glue on fabric

19 × 12¾ in. (48.2 × 32.4 cm)

Collection of Connie Fails

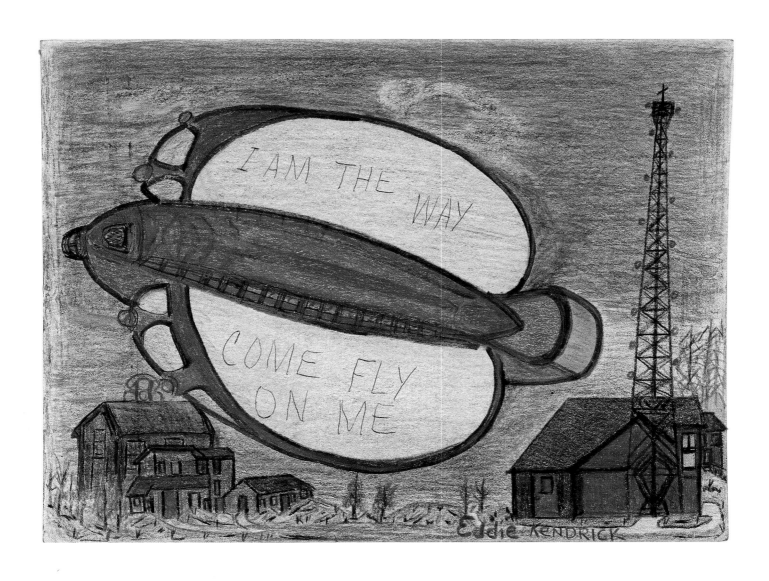

**22**

*I Am the Way—Come Fly on Me,* c. 1992
Colored pencil and ballpoint pen
on paper mounted on posterboard
9 × 12 in. (22.9 × 30.5 cm)
Private collection

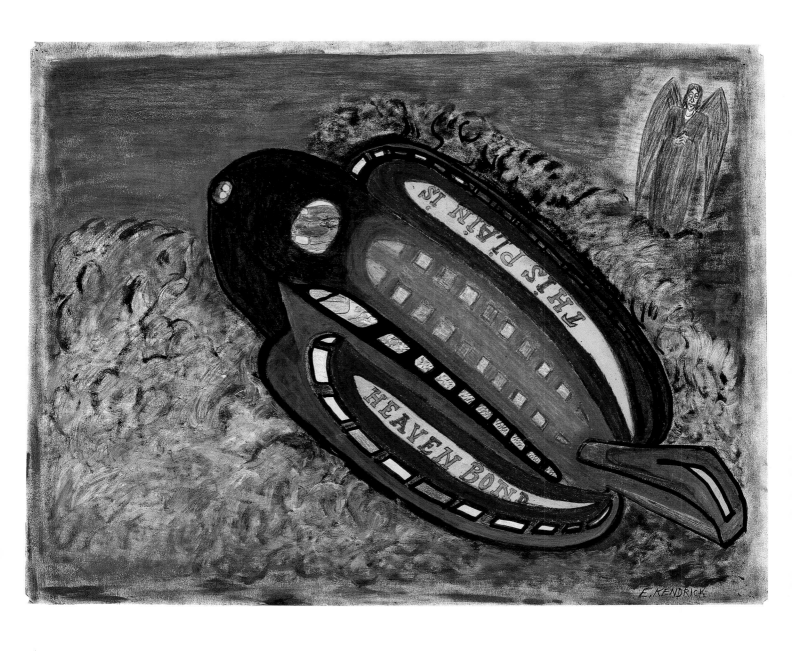

**23**

*This Plane Is Heaven Bound*, c. 1992

Colored pencil, oil, marker, ballpoint pen,

and paint on posterboard

19 × 24 in. (48.5 × 61 cm)

Collection of Susan C. Yelen

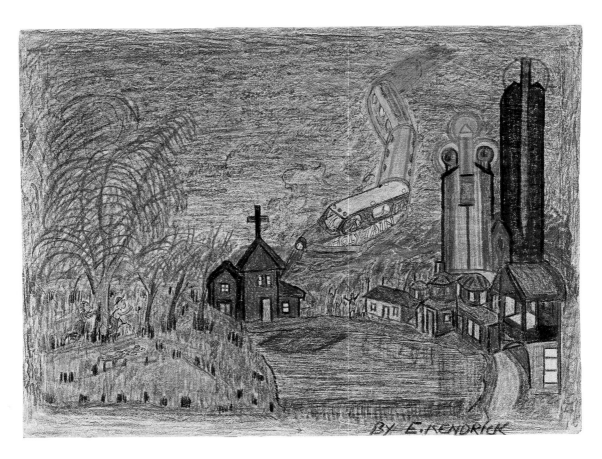

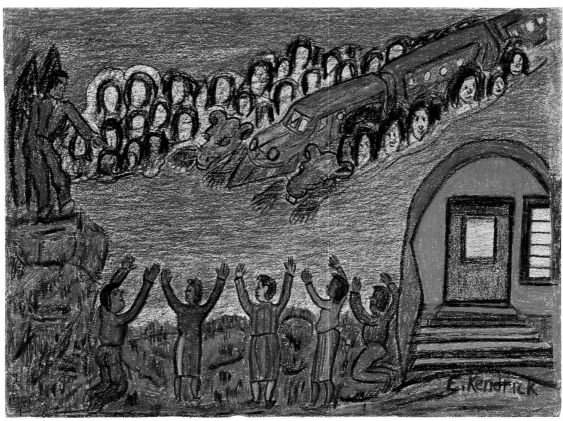

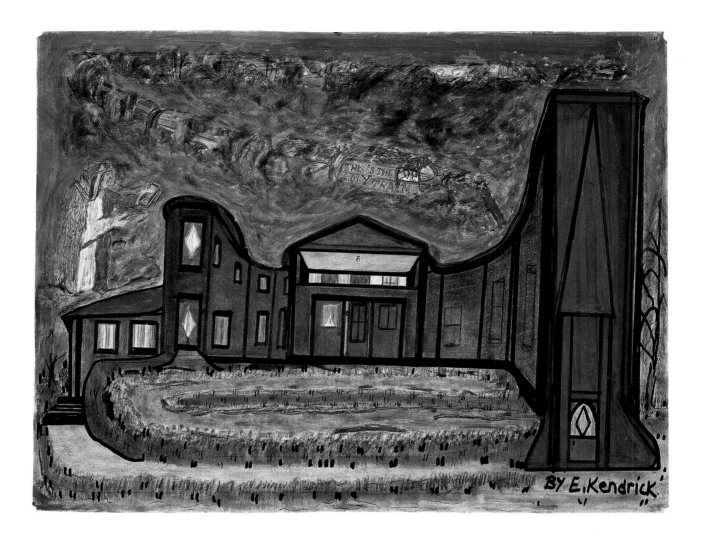

24
*Holy Train,* c. 1992
Pencil, colored pencil, ballpoint pen,
and marker on paper mounted
on posterboard
9 × 12 in. (22.9 × 30.5 cm)
Private collection

26
*This Is the Holy Train,* c. 1992
Oil, colored pencil, ballpoint pen,
and marker on posterboard
19 × 24 in. (48.5 × 61 cm)
Collection of Dorothy and
David Harman

25
*Train from Heaven,* c. 1992
Colored pencil and ballpoint pen
on paper mounted on posterboard
9 × 12 in. (22.9 × 30.5 cm)
Private collection

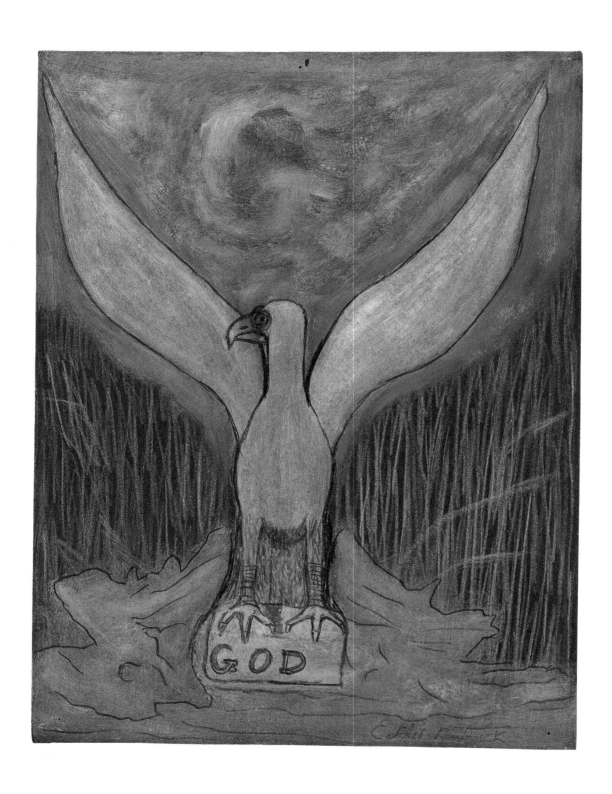

**27**

*Bird in Wintry Blue Landscape,* c. 1992

Oil and colored pencil on paper

12 × 9 in. (30.5 × 22.9 cm)

Private collection

**28**

*Bird over Landscape with the Eye of God Above*, c. 1992
Colored pencil, ballpoint pen, and ink on paper
9 × 12 in. (22.9 × 30.5 cm)
New Orleans Museum of Art, gift of Alice Rae Yelen and Dr. Kurt A. Gitter, 1997.40

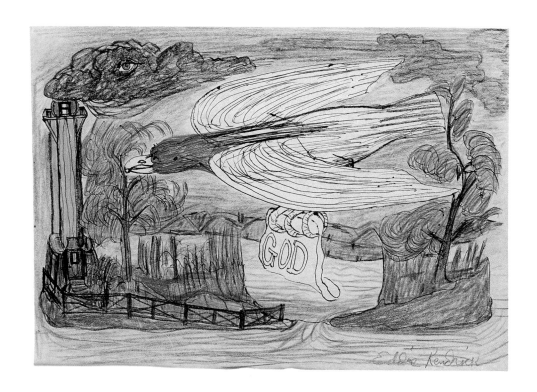

**29**

*City Coming Down with Bird Descending*, c. 1992
Colored pencil and ballpoint pen on paper
9 × 12 in. (22.9 × 30.5 cm)
Private collection

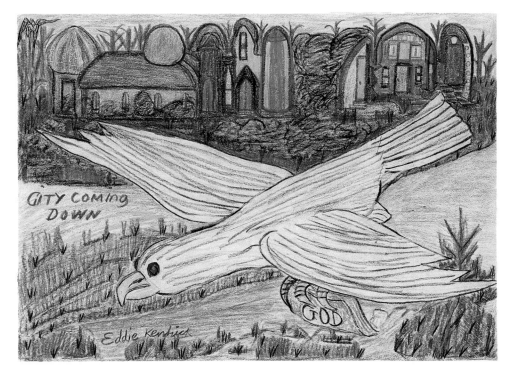

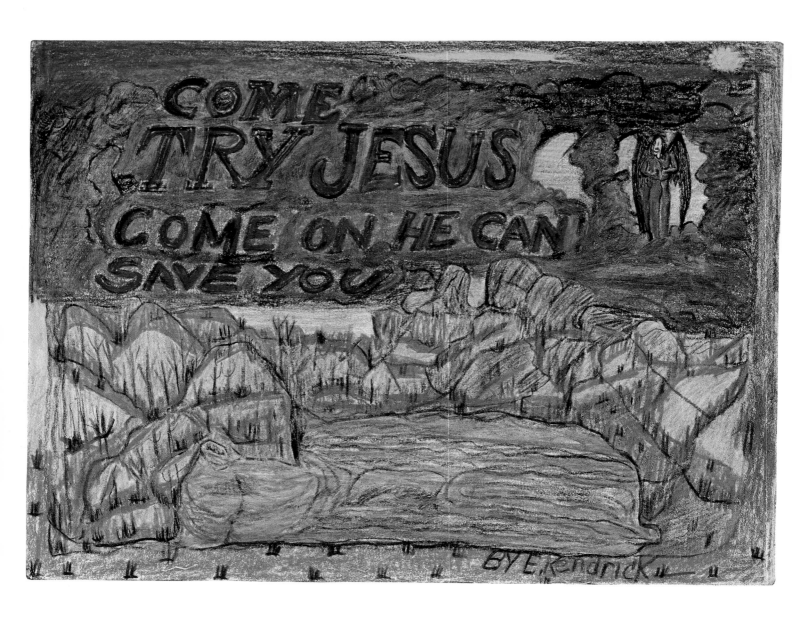

30

*Come Try Jesus*, c. 1992

Colored pencil, oil, and ballpoint pen

on paper mounted on posterboard

9 × 12 in. (22.9 × 30.5 cm)

Private collection

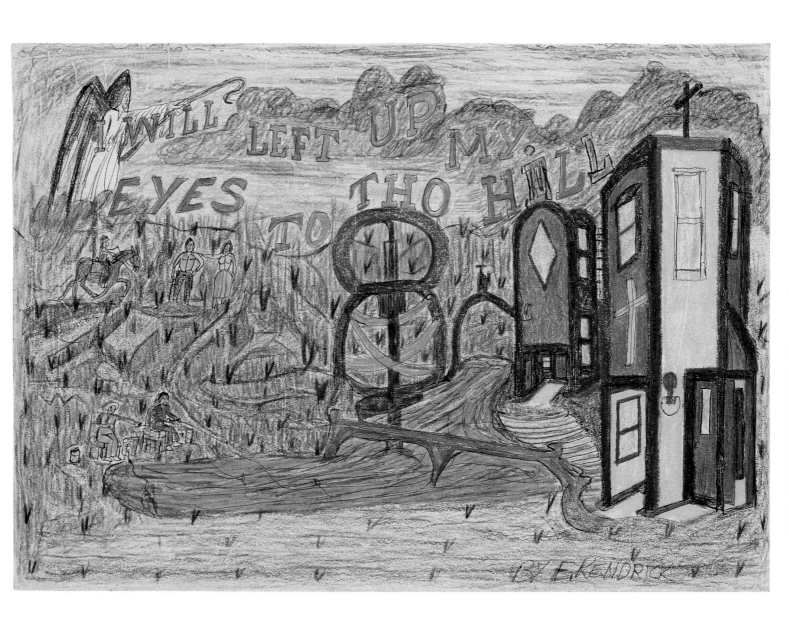

31
*I Will Lift Up My Eyes to the Hill,* c. 1992
Colored pencil and ballpoint pen
on paper mounted on posterboard
9 × 12 in. (22.9 × 30.5 cm)
Private collection

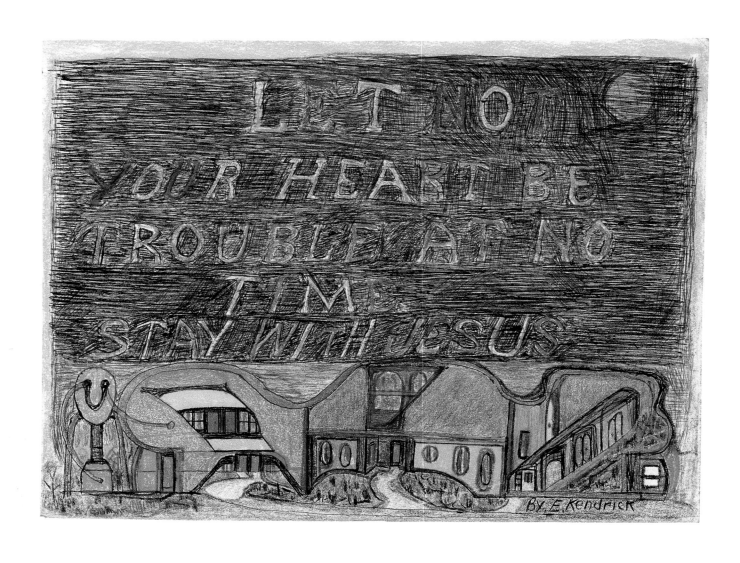

32

*Let Not Your Heart Be Troubled at No Time*, c. 1992

Colored pencil and ballpoint pen on paper

9 × 12 in. (22.9 × 30.5 cm)

Private collection

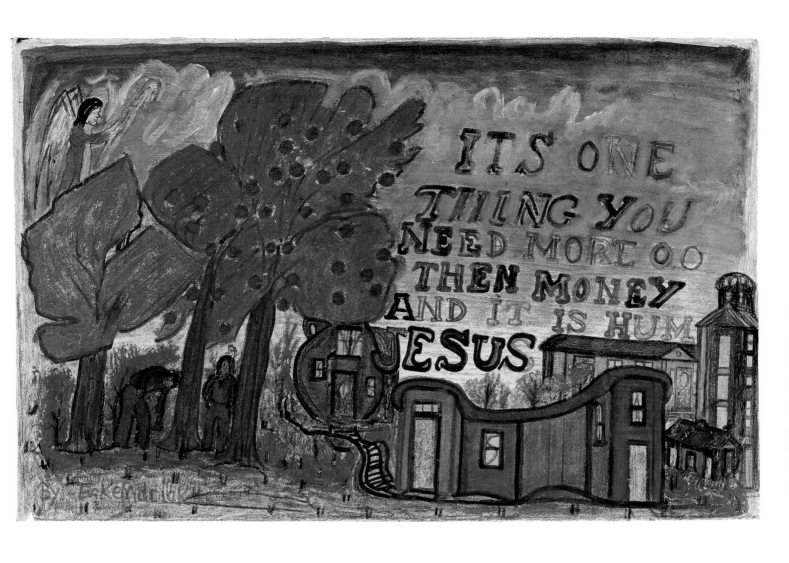

33
*It's One Thing You Need More than Money*, c. 1992
Oil, colored pencil, and marker on paper
mounted on posterboard
12 × 18 in. (30.5 × 45.7 cm)
Private collection

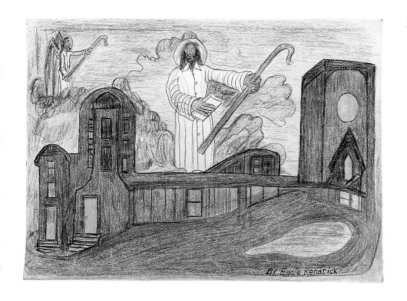

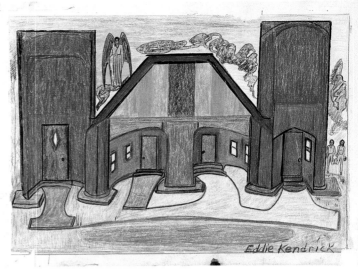

**34**
*City with Christ Above,* c. 1992
Colored pencil, pencil, and ballpoint pen on paper
9 × 12 in. (22.9 × 30.5 cm)
Collection of E. John Bullard

**35**
*Red and Green Building,* c. 1991
Colored pencil and ballpoint pen on paper
9 × 12 in. (22.9 × 30.5 cm)
Collection of Robert Allison

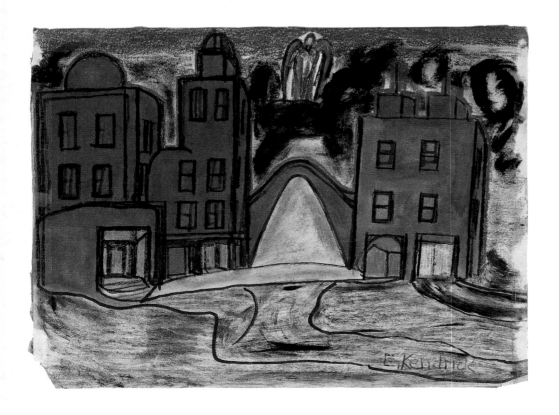

**36**
*Brown Buildings Connected
by Golden Arch,* c. 1991
Oil, marker, and colored pencil on paper
9 × 12 in. (22.9 × 30.5 cm)
Collection of Tiffany Allison

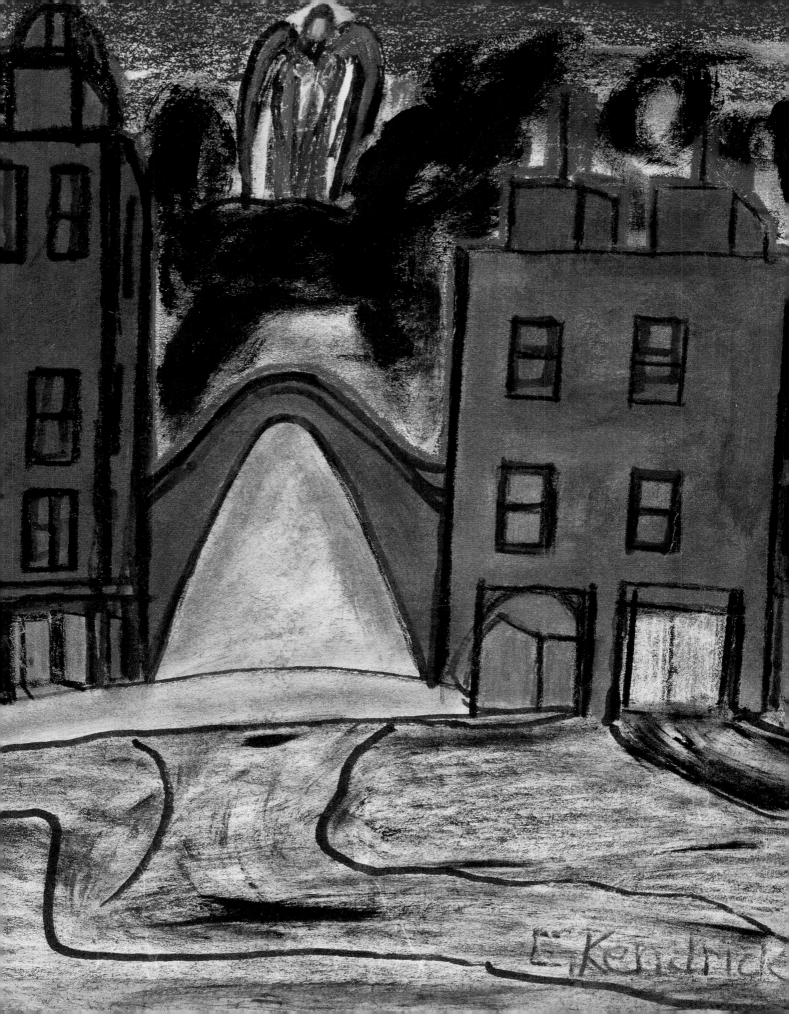

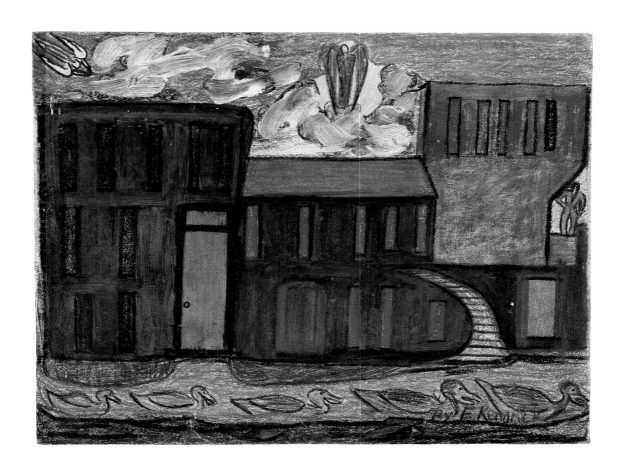

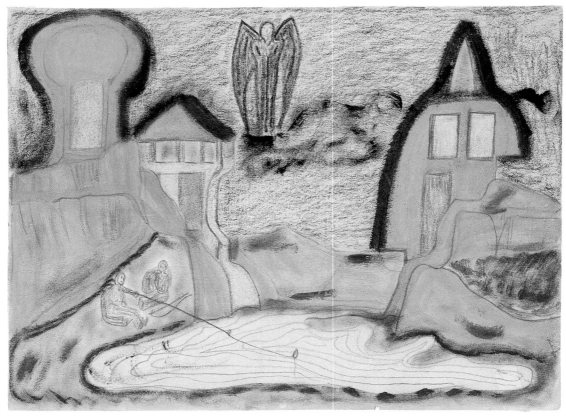

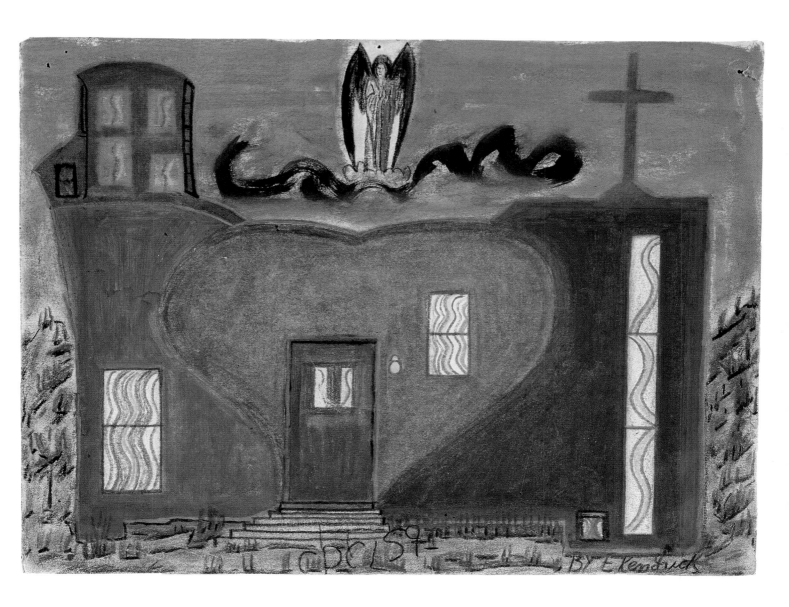

**37**
*Ducks in Front of Buildings,* c. 1991
Colored pencil and oil on paper mounted
on illustration board
9 × 12 in. (22.9 × 30.5 cm)
Collection of Suzanne Clark Golden

**38**
*Brown Structures with Angel,* c. 1991
Oil, colored pencil, and pencil on paper
9 × 12 in. (22.9 × 30.5 cm)
Collection of Crystal Jones

**39**
*Green Heart-Shaped House,* c. 1991
Oil and colored pencil on paper
9 × 12 in. (22.9 × 30.5 cm)
Collection of Crystal Jones

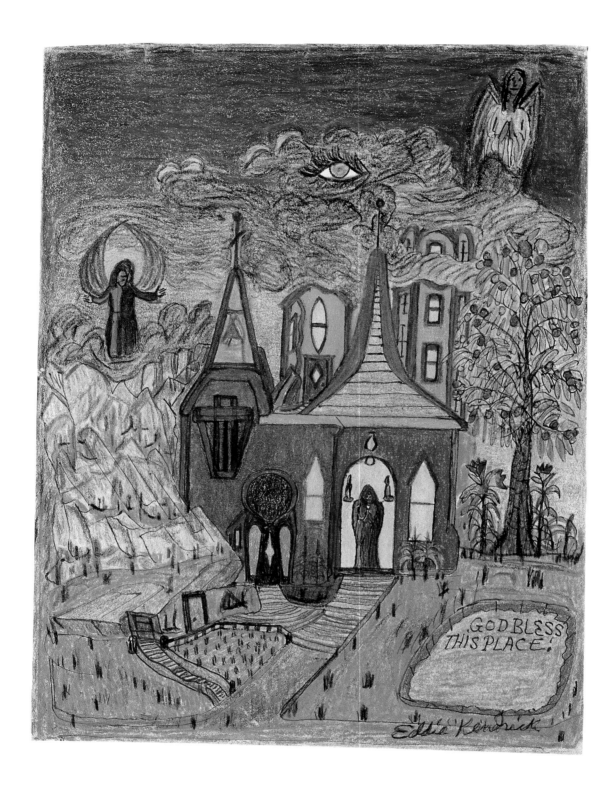

40

*God Bless This Place!*, c. 1992

Colored pencil, oil, ballpoint pen, and pencil

on paper mounted on posterboard

12 × 9 in. (30.5 × 22.9 cm)

Private collection

41

*A Bed in the Sun*, c. 1992

Colored pencil, oil, and ballpoint pen

on paper mounted on posterboard

12 × 9 in. (30.5 × 22.9 cm)

Private collection

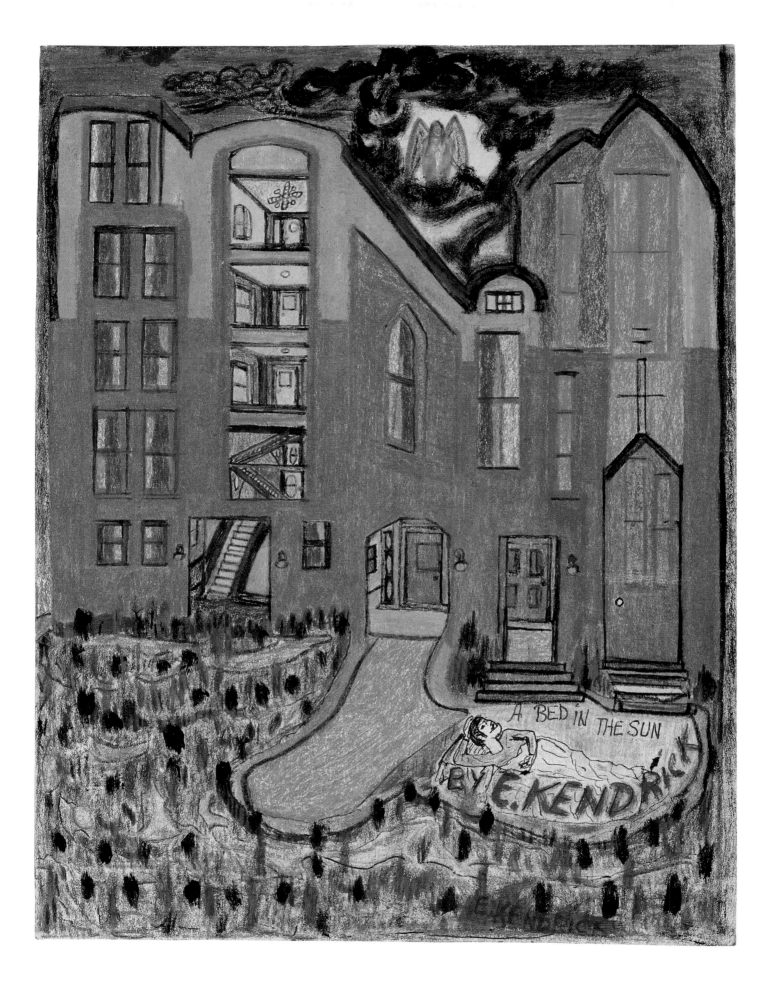

A BED IN THE SUN

BY E. KENDRICK

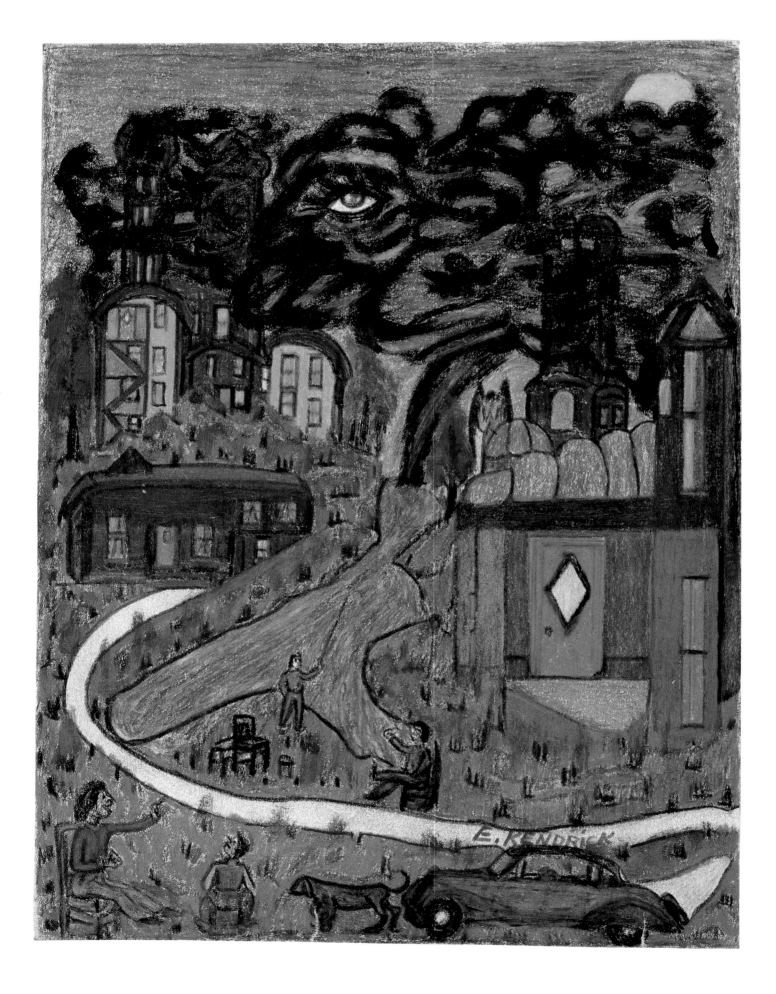

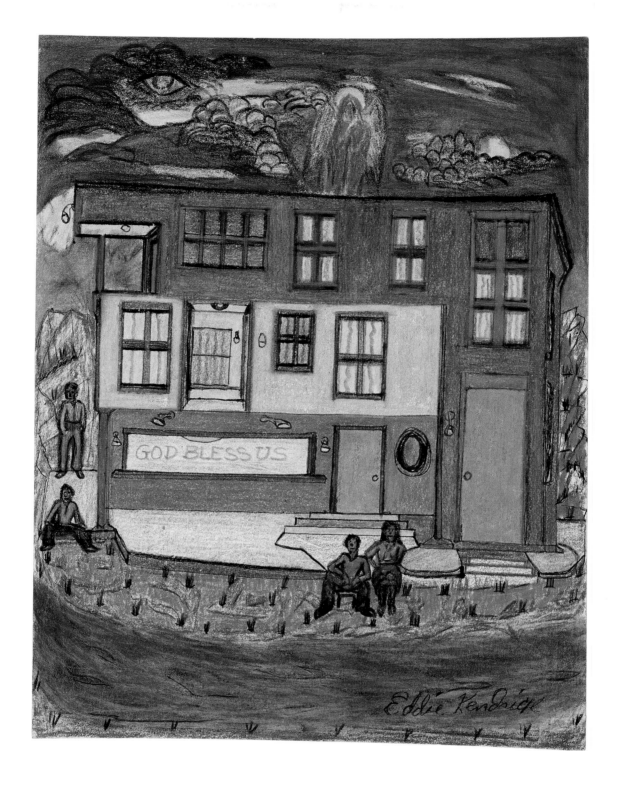

<table>
<tr><td align="center">42</td><td align="center">43</td></tr>
</table>

| 42 | 43 |
|----|----|
| *Landscape Eye of God and Dark Clouds*, c. 1992 | *God Bless Us*, c. 1992 |
| Colored pencil, oil, and ballpoint pen | Colored pencil, oil, and ballpoint pen |
| on paper mounted on posterboard | on paper mounted on posterboard |
| 12 × 9 in. (30.5 × 22.9 cm) | 12 × 9 in. (30.5 × 22.9 cm) |
| Private collection | Private collection |

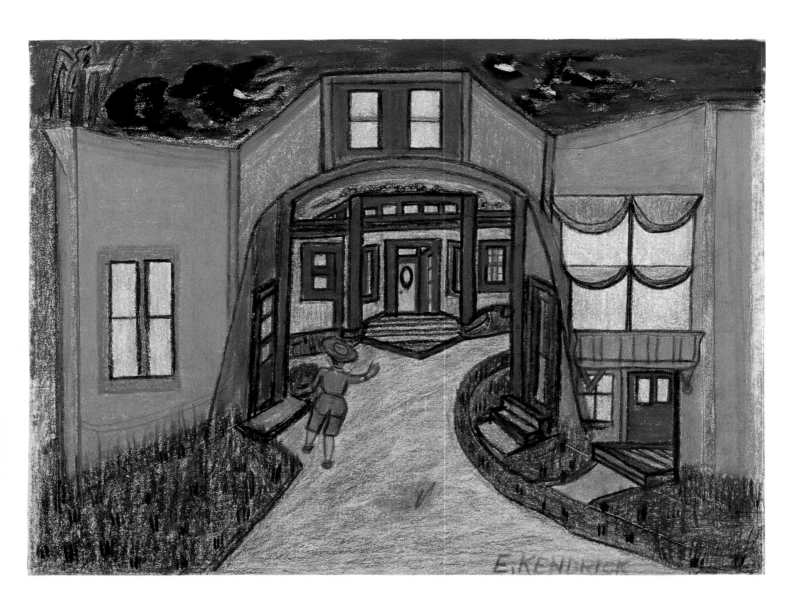

**44**

*Revelation* 17:18, c. 1990–91
Colored pencil, oil, and ballpoint pen
on paper mounted on posterboard
9 × 12 in. (22.9 × 30.5 cm)
Collection of Melverue Abraham

**45**
*Connected Structures with Propeller*, c. 1992
Oil, colored pencil, and ballpoint pen on paper
9 × 12 in. (22.9 × 30.5 cm)
Private collection

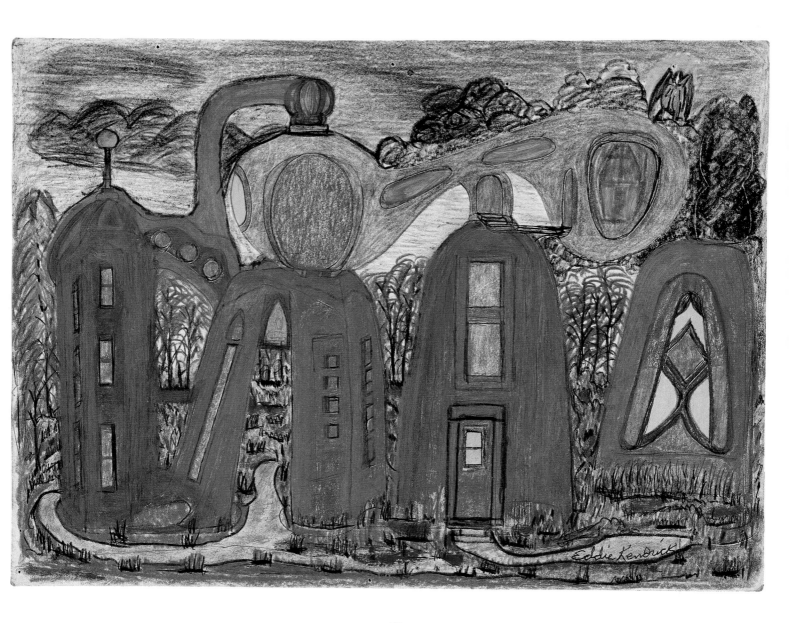

**46**

*Red Connected Structures with Cross,* c. 1992

Oil, colored pencil, marker,

and pencil on paper

12 × 18 in. (30.5 × 45.7 cm)

Private collection

**47**

*Heavenly City with Delivery Trucks,* c. 1992

Colored pencil and ballpoint pen

on paper mounted on posterboard

12 × 9 in. (30.5 × 22.9 cm)

Private collection

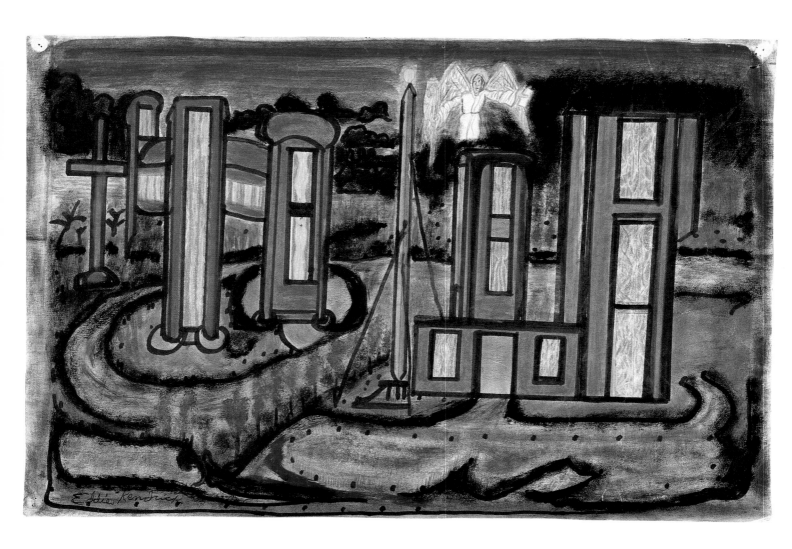

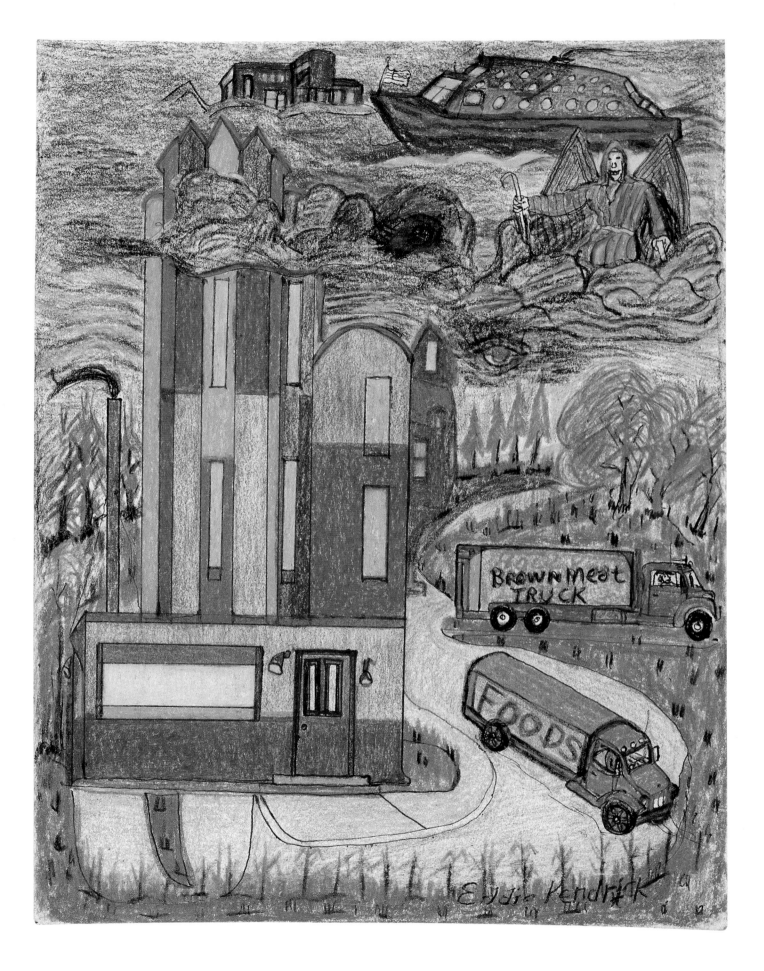

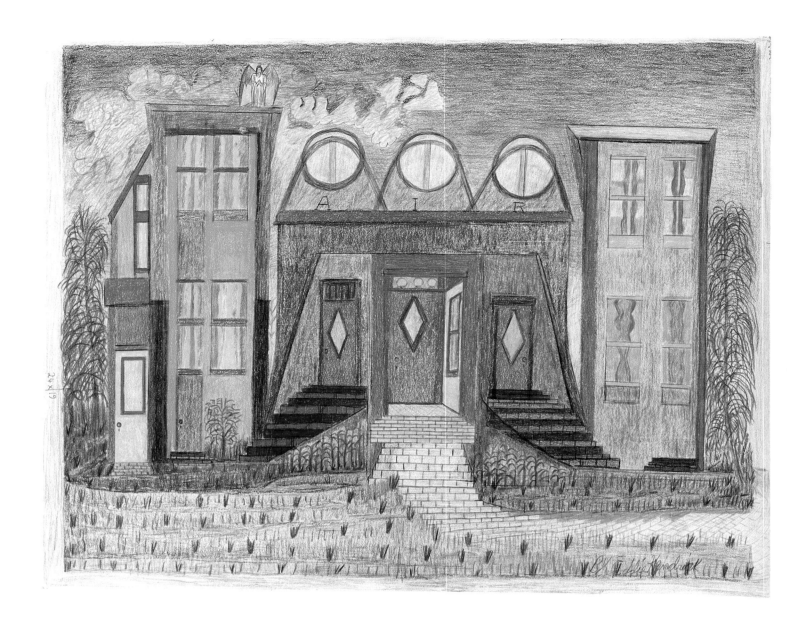

**48**

*Fantasy Building-Air*, c. 1992
Colored pencil, pencil, and ballpoint pen on paper
19 × 24 in. (48.2 × 58.4 cm)
Private collection

## 49

*Fantastical Building with Angel*, c. 1992
Colored pencil and oil on paper
12 × 9 in. (30.5 × 22.9 cm)
San Diego Museum of Art, gift of Alice Rae Yelen
and Dr. Kurt A. Gitter in honor of
Charmaine and Maurice Kaplan, 1995.011

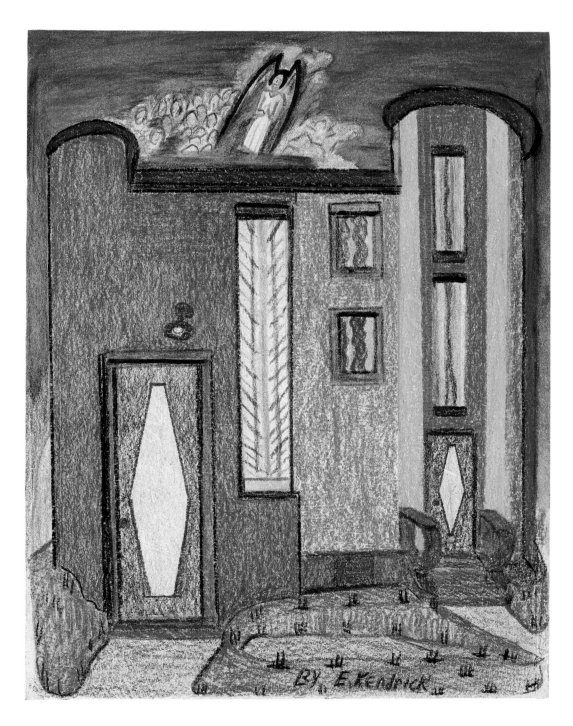

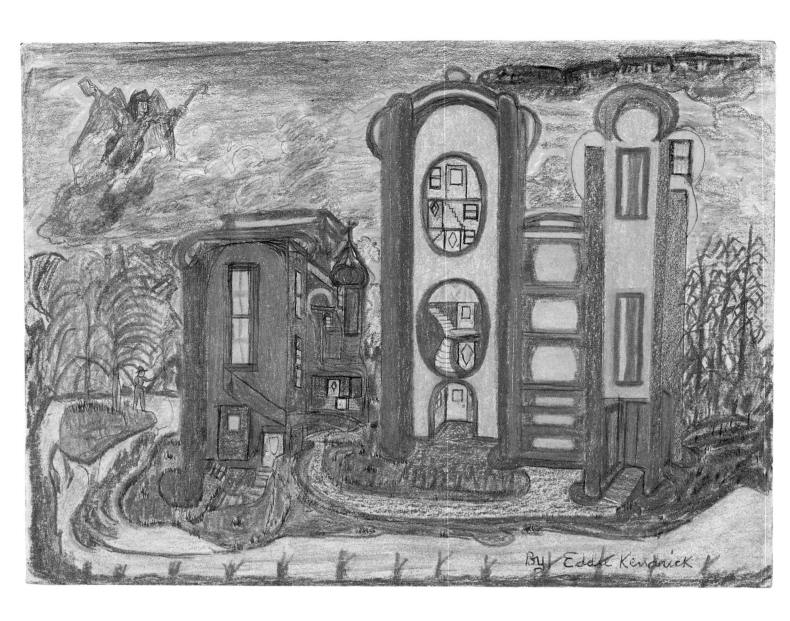

50
*Fantastical Red Buildings with Angel Above*, c. 1992
Colored pencil, oil, and ballpoint pen
on paper mounted on posterboard
9 × 12 in. (22.9 × 30.5 cm)
New Orleans Museum of Art,
gift of Alice Rae Yelen and
Dr. Kurt A. Gitter, 1993.398

51
*Tree of Life*, c. 1992
Colored pencil, oil, and
ballpoint pen on paper
18 × 12 in. (45.7 × 30.5 cm)
Private collection

GOD
BLESS YOU ALL!                    BY F.kendrick

52
*Rocket Ship with Angel,* c. 1991
Colored pencil, oil, pencil, and
ballpoint pen, on paper
9 × 12 in. (22.9 × 30.5 cm)
Collection of Laura Sanders

53
*Fishing Buoy,* c. 1992
Colored pencil, oil, and ballpoint pen
on paper mounted on posterboard
12 × 9 in. (30.5 × 22.9 cm)
Private collection

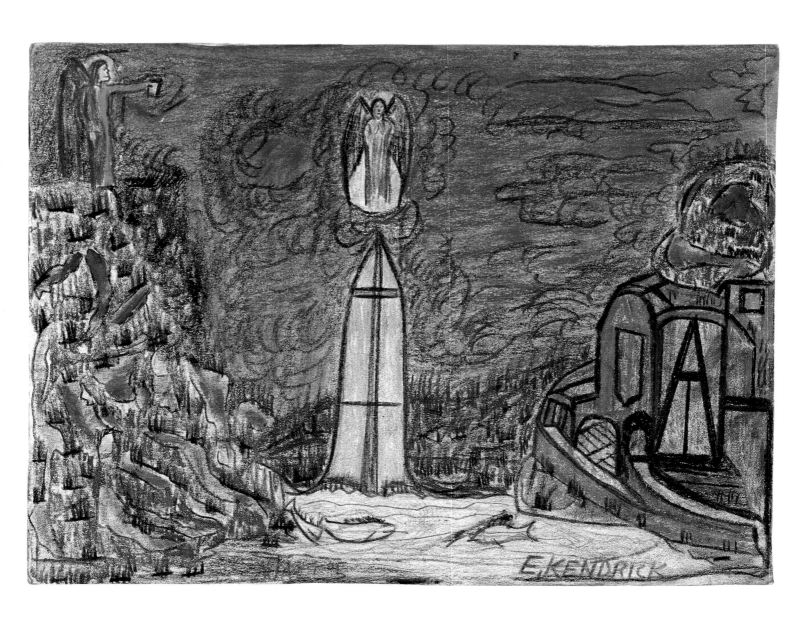

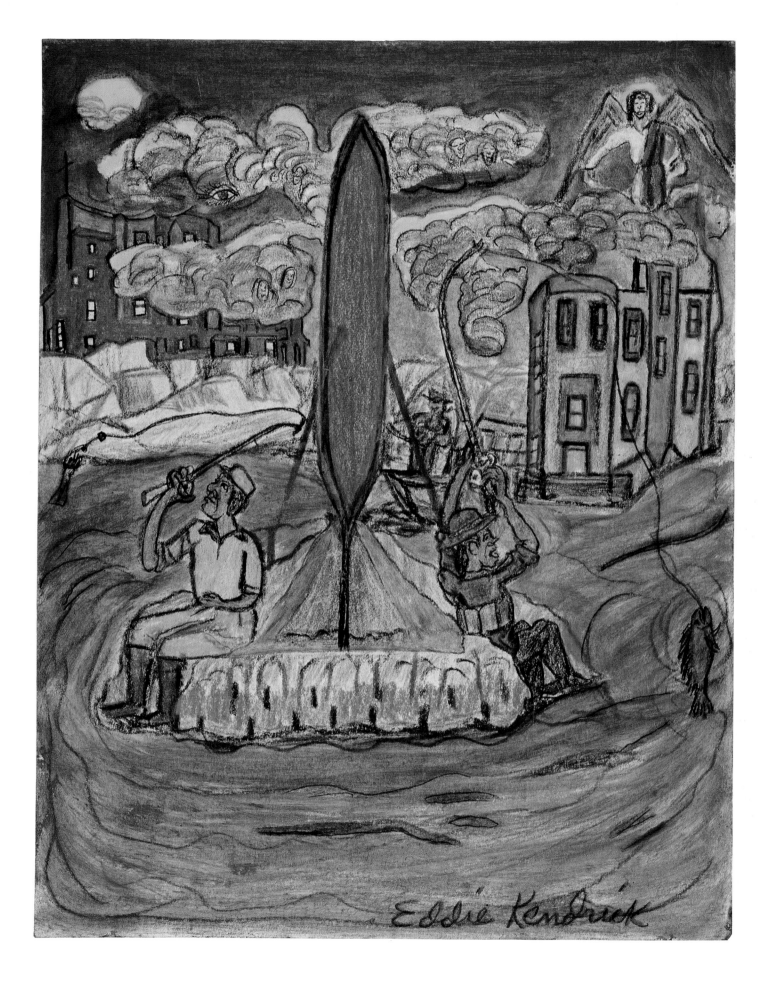

54

*Rippled Landscape*, c. 1977/1992
Tempera, acrylic, oil, colored pencil,
and ballpoint pen on corrugated cardboard
16¼ × 27¼ in. (41.3 × 69.2 cm)
Private collection

## 55

*Architectural Panorama with Baptism*, c. 1991
Oil and colored pencil on fabric
25 × 40 in. (63.5 × 101.5 cm)
Collection of Will Staley

56

*Horses and Red/Brown Houses,* c. 1991
Colored pencil, oil, and ballpoint pen
on paper mounted on illustration board
9 × 12 in. (22.9 × 30.5 cm)
Collection of Brandon L. Reeves

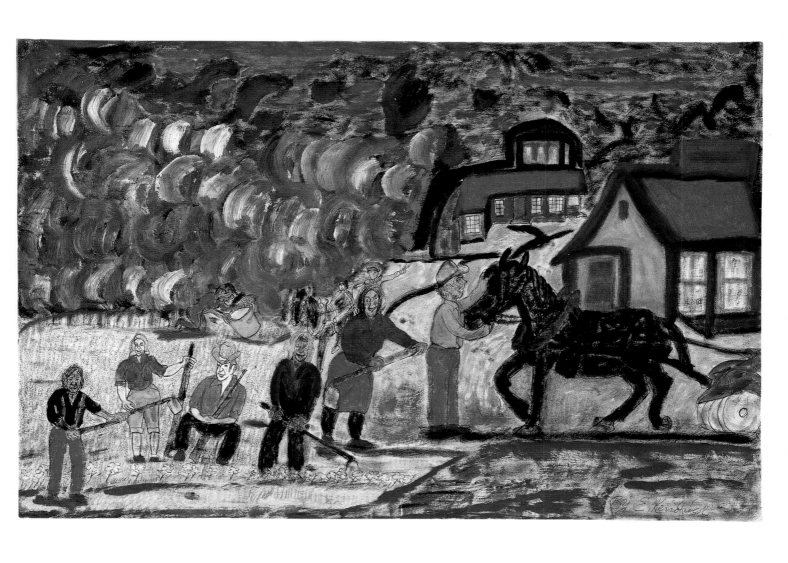

*57*

*People with Horse and Houses,* c. 1991

Oil, colored pencil, ballpoint pen, and pencil on paper

12 × 18 in. (30.5 × 45.7 cm)

Collection of McDowell and Mary Nell Turner

58

*Two Men Fishing*, c. 1991

Oil, colored pencil, and pencil on paper

9 × 12 in. (22.9 × 30.5 cm)

Collection of Jonathan Fields

59

*My Dream*, c. 1992

Colored pencil, oil, and ballpoint pen on paper

mounted on posterboard

12¼ × 9¾ in. (31.1 × 24.8 cm)

Private collection

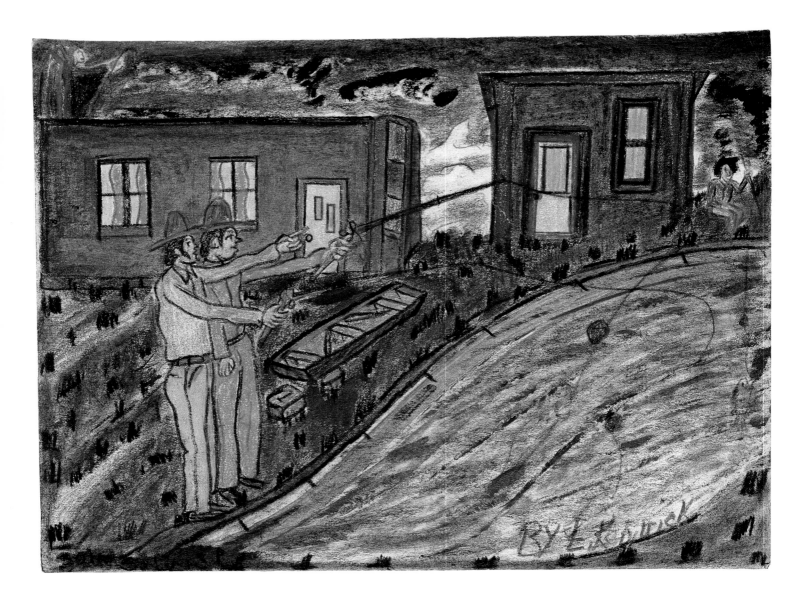

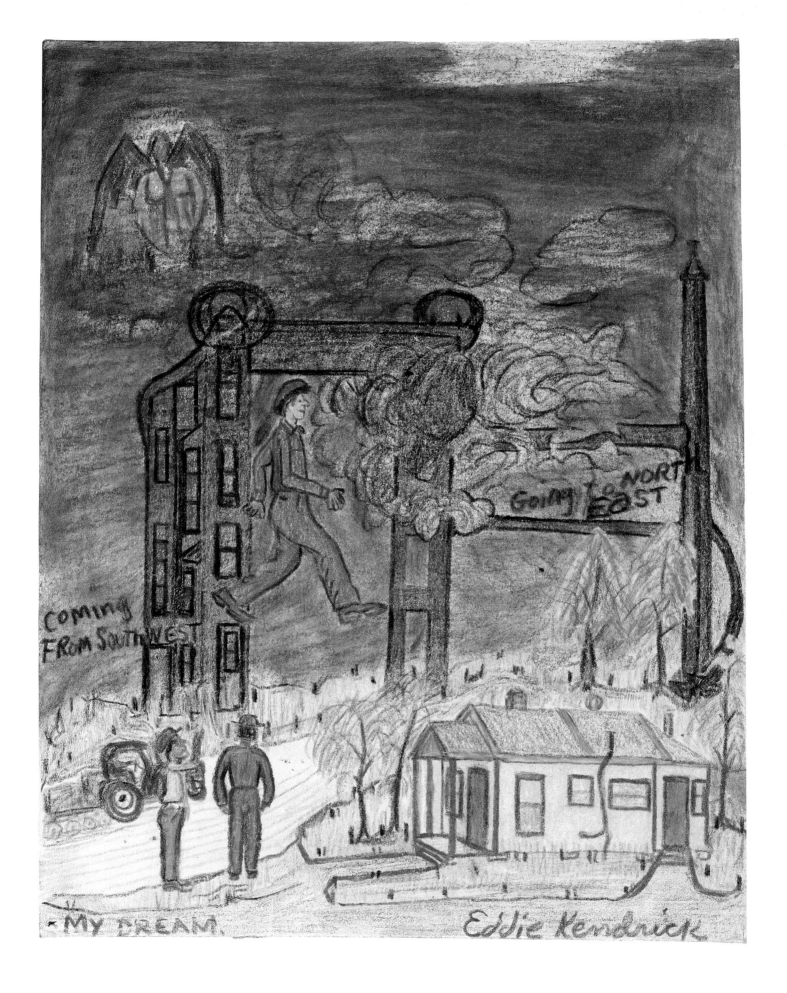

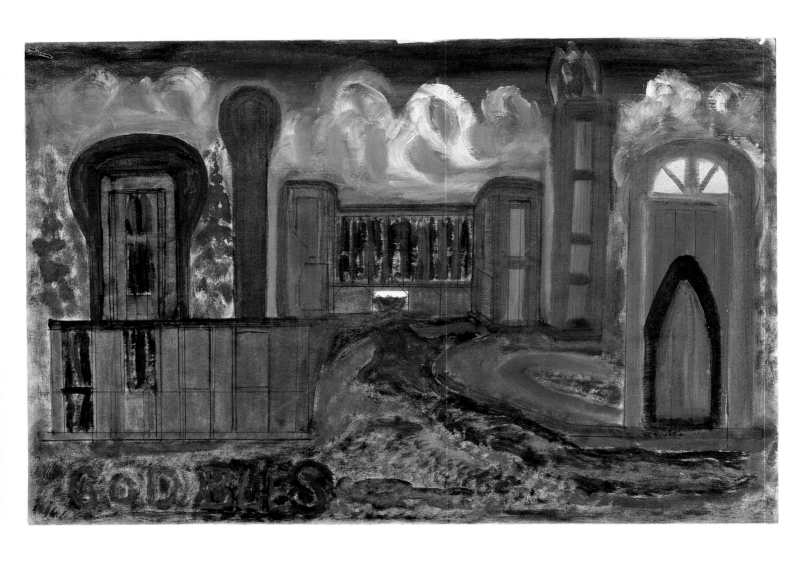

60

*God Bless*, c. 1991

Oil, colored pencil, and ballpoint pen on paper

12 × 18 in. (30.5 × 45.7 cm)

Collection of the Kendrick Family

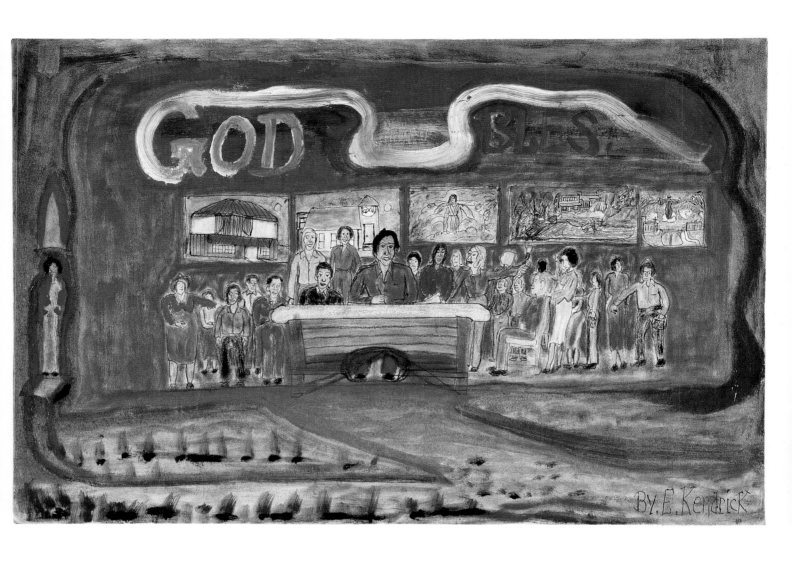

61

*God Bless*, c. 1991

Oil, colored pencil, and ballpoint pen on paper

12 × 18 in. (30.5 × 45.7 cm)

Collection of Joseph H. and Susan Turner Purvis

62

*Figures with Black Snake and Dancing,* c. 1991
Oil, colored pencil, pencil, and ballpoint pen on paper
18½ × 24 in. (47.0 × 58.4 cm)
The Arkansas Arts Center, given on behalf of the
Children of Gibbs Magnet School, 1990–91, 95.29

63
*The House of Blessing,* c. 1992
Colored pencil and ballpoint pen on paper
19 × 24 in. (48.2 × 58.4 cm)
Private collection

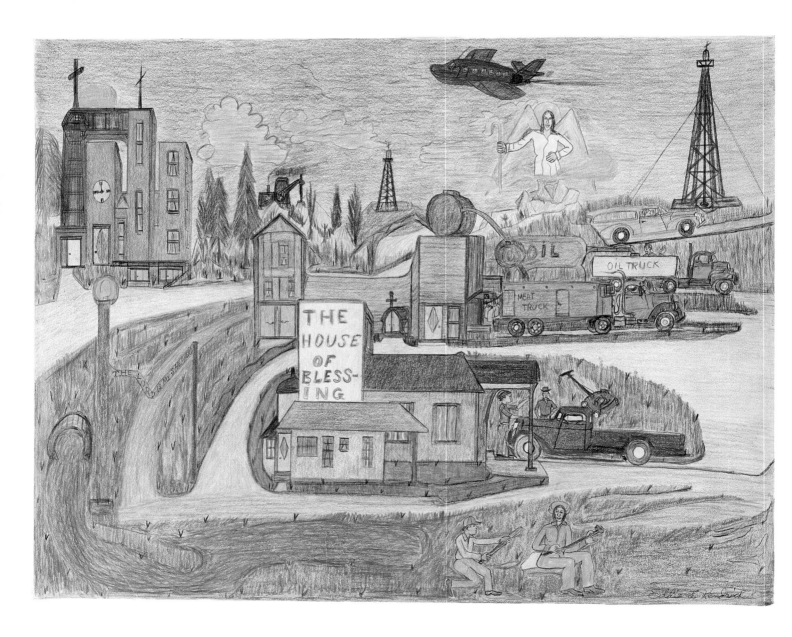

**64**

*The Lord Is My Strength*, c. 1992
Ballpoint pen on paper
9 × 12 in. (22.9 × 30.5 cm)
Private collection

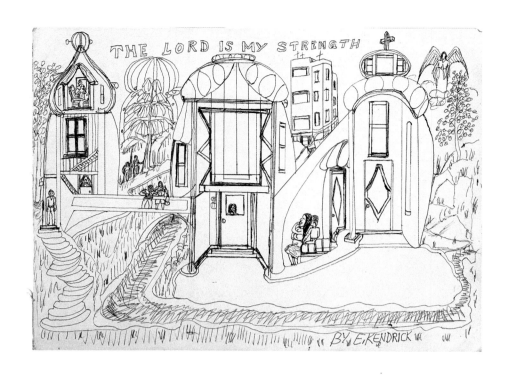

**65**

*Architectural Drawing with
Cross and Steps*, c. 1992
Ballpoint pen on paper
9 × 12 in. (22.9 × 30.5 cm)
Collection of the Kendrick Family

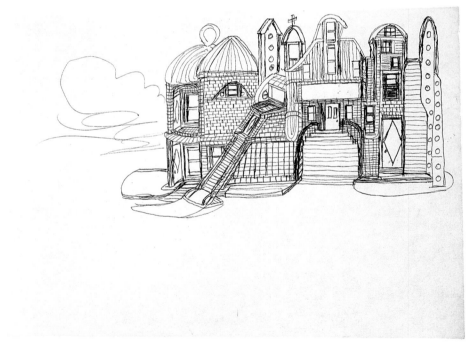

# BIBLIOGRAPHY

Gunter, Beti. "Brothers Share Hobby: Their Art Is for Others." *Arkansas Gazette,* March 13, 1977, p. D2.

"Where the Action Is: Parham." *The Kite* (Little Rock School District/Arts in Education Newsletter), April 1978, p. 3.

*Arkansas Democrat Gazette,* February 8, 1991, p. B2.

"Eddie Lee Kendrick" (obituary). *Arkansas Democrat Gazette,* November 24, 1992, p. B6.

Shores, Elizabeth F. *Explorers' Classrooms: Good Practice for Kindergarten and the Primary Grades.* Little Rock: Southern Association on Children Under Six, 1992, p. 66, pl. 6-5.

Yelen, Alice Rae. *Passionate Visions of the American South: Self-Taught Artists from 1940 to the Present.* New Orleans: New Orleans Museum of Art; Jackson, Miss.: University Press of Mississippi, 1993, pp. 49, 138, 160, 316.

Purvis, Susan Turner. "Eddie Lee Kendrick: Art and Soul." *Dimensions of Early Childhood* 23 (fall 1995): 35–37.

Schwindler, Gary J. "Eddie Kendrick." In *Pictured in My Mind: Contemporary American Self-Taught Art,* edited by Gail Andrews Trechsel, pp. 108–9. Birmingham: Birmingham Museum of Art, dist. by University Press of Mississippi, 1995.

*Something Wonderful: Artists Outside the Mainstream.* San Francisco: Chronicle Books, 1995, pp. 43–44, back cover.

Purvis, Susan Turner. "Eddie Kendrick: An *Other* Teacher." *AAE* (Arkansas Art Educators) *News* 10 (February 1996): 4–5.

Rosenak, Chuck and Jan Rosenak. *Contemporary American Folk Art: A Collector's Guide.* New York: Abbeville Press, 1996, pp. 138, 160, 182.

"Art Exhibitions Debut at Central." *Central High School's Parent Teacher Student Association Newsletter* (Little Rock), February 1997, p. 2.